CAPTURING THE MAGIC OF LIGHT IN WATERCOLOR

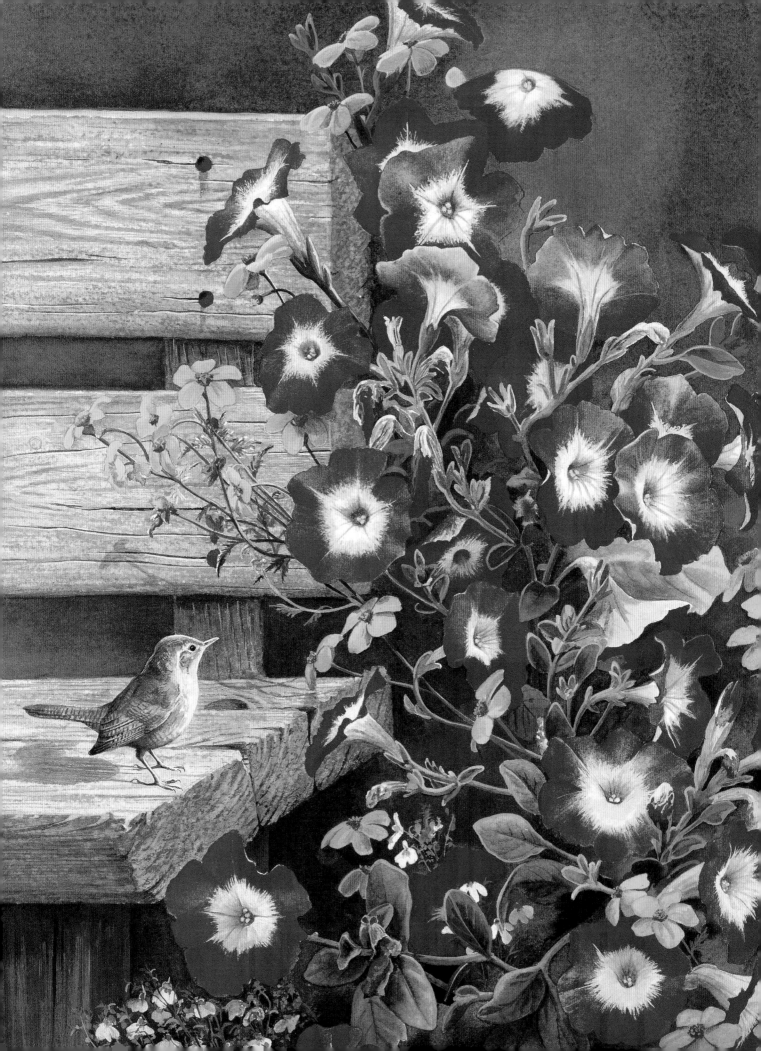

Capturing the
MAGIC
of LIGHT
in watercolor

SUSAN D. BOURDET

NORTH LIGHT BOOKS

CINCINNATI, OHIO

www.artistsnetwork.com

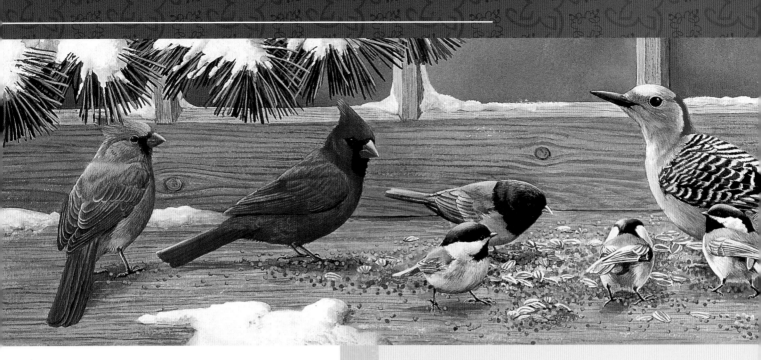

fw
F+W PUBLICATIONS, INC.

Other fine North Light Books are available from your local bookstore, art supply store or direct from the publisher.

09 08 07 06 05 5 4 3 2 1

DISTRIBUTED IN CANADA BY FRASER DIRECT
100 Armstrong Avenue
Georgetown, ON, Canada L7G 5S4
Tel: (905) 877-4411

DISTRIBUTED IN THE U.K. AND EUROPE BY DAVID & CHARLES
Brunel House, Newton Abbot, Devon, TQ12 4PU, England
Tel: (+44) 1626 323200, Fax: (+44) 1626 323319
Email: mail@davidandcharles.co.uk

DISTRIBUTED IN AUSTRALIA BY CAPRICORN LINK
P.O. Box 704, S. Windsor NSW, 2756 Australia
Tel: (02) 4577-3555

Library of Congress Cataloging in Publication Data
Bourdet, Susan D.
 Capturing the magic of light in watercolor / Susan D. Bourdet.
 p. cm
 Includes index.
 ISBN 1-58180-583-7 (hardcover : alk. paper)
 1. Watercolor painting--Technique. 2. Light in art. I. Title.

ND2420.B68 2005
751.42'2--dc22 00-068694

Edited by Stefanie Laufersweiler and Amy Jeynes
Designed by Wendy Dunning
Production art by Lisa Holstein
Production coordinated by Mark Griffin

To Brian

I dedicate this book in loving memory of my nephew and "birthday buddy," Brian Matthew Nolan. In his twenty-two years of life, Brian discovered his gift of music and worked tirelessly to refine it. Few of us are able to jump in and go that confidently in the direction of our dreams. Beyond that, he found in his short lifetime a way to give his gift to others, sharing joy, hope and inspiration with young people. His life showed me that, whatever your "song," you never truly own it until you give it away.

Metric Conversion Chart

To convert	to	multiply by
Inches	Centimeters	2.54
Centimeters	Inches	0.4
Feet	Centimeters	30.5
Centimeters	Feet	0.03
Yards	Meters	0.9
Meters	Yards	1.1
Sq. Inches	Sq. Centimeters	6.45
Sq. Centimeters	Sq. Inches	0.16
Sq. Feet	Sq. Meters	0.09
Sq. Meters	Sq. Feet	10.8
Sq. Yards	Sq. Meters	0.8
Sq. Meters	Sq. Yards	1.2
Pounds	Kilograms	0.45
Kilograms	Pounds	2.2
Ounces	Grams	28.3
Grams	Ounces	0.035

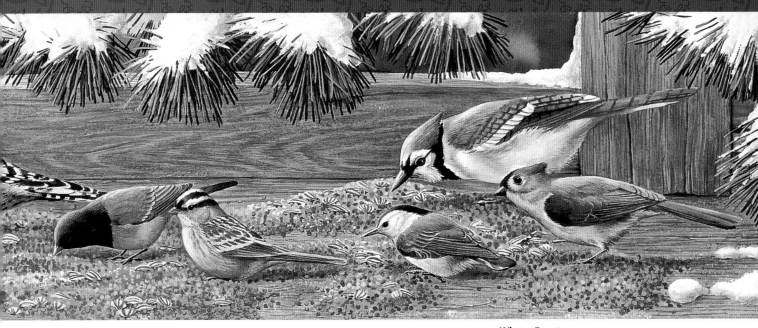

Winter Feast
Watercolor and gouache on 300-lb. (640gsm) Arches
cold-pressed paper
9" x 36" (23cm x 91cm)

ABOUT THE AUTHOR

Susan Bourdet grew up in western Montana, learning early to love nature. Her luminous watercolors combine realistically detailed birds and animals with soft, impressionistic backgrounds, a technique that has evolved through her twenty years of painting.

Susan majored in art and biology, her two great loves, while at Montana State University. After graduation, she struggled to find a way to combine her two interests. Her career as a professional artist didn't really begin until 1980, when she was raising her two children and needed to work at home. She joined a support group of nature artists and began to show her work in local galleries. In 1989, her paintings were discovered in an Oregon gallery by Wild Wings. She now has over sixty limited editions, and her work is featured in a yearly songbirds calendar published by Bookmark. She is the author of *Painting the Allure of Nature* (North Light Books, 2001). Her newest instructional venture is a video titled *Bold and Beautiful: Backyard Wildlife in Watercolor*, produced by Creative Catalyst Productions. Her paintings have been featured in shows and exhibitions all over the country, including the Leigh Yawkey Woodson Art Museum's *Birds in Art* and the Society of Animal Artists' *Art and the Animal*.

Susan lives with her husband, Jim, and children, Rachael and Dan on several acres of wild woodland, which provide settings and subjects for her artwork. An avid gardener, she combines this interest with her art by planting her yard with favorite flowers and creating a pond and waterfall to attract wildlife. She enjoys sharing her unique methods and insights with other artists and nature lovers in watercolor workshops and seminars.

See and purchase art at Susan's website, www.susanbourdet.com.

ACKNOWLEDGMENTS

I'd like to thank my students for the wealth of inspirational stories and for the overwhelming enthusiasm they have shared with me. From them I have learned how blessed artists are to be doing what they do best and what they love best. Seeing painting through my students' eyes has kept me energized.

TABLE OF CONTENTS

1 | GETTING STARTED 10

This chapter covers the materials you'll need and introduces light and color basics. You'll learn about the properties of watercolors, how they mix and how they work in a painting.

2 | INSPIRATION, DOCUMENTATION AND DESIGN 22

For a painting to really sing, it needs to express what captivates you about your subject. This chapter will teach you how to capture your very own idea with reference photographs and how to create an appealing and effective design.

3 | BASIC WATERCOLOR TECHNIQUES 36

A blank sheet of paper is a fearsome prospect. This chapter will help you conquer that fear by learning the basic watercolor techniques.

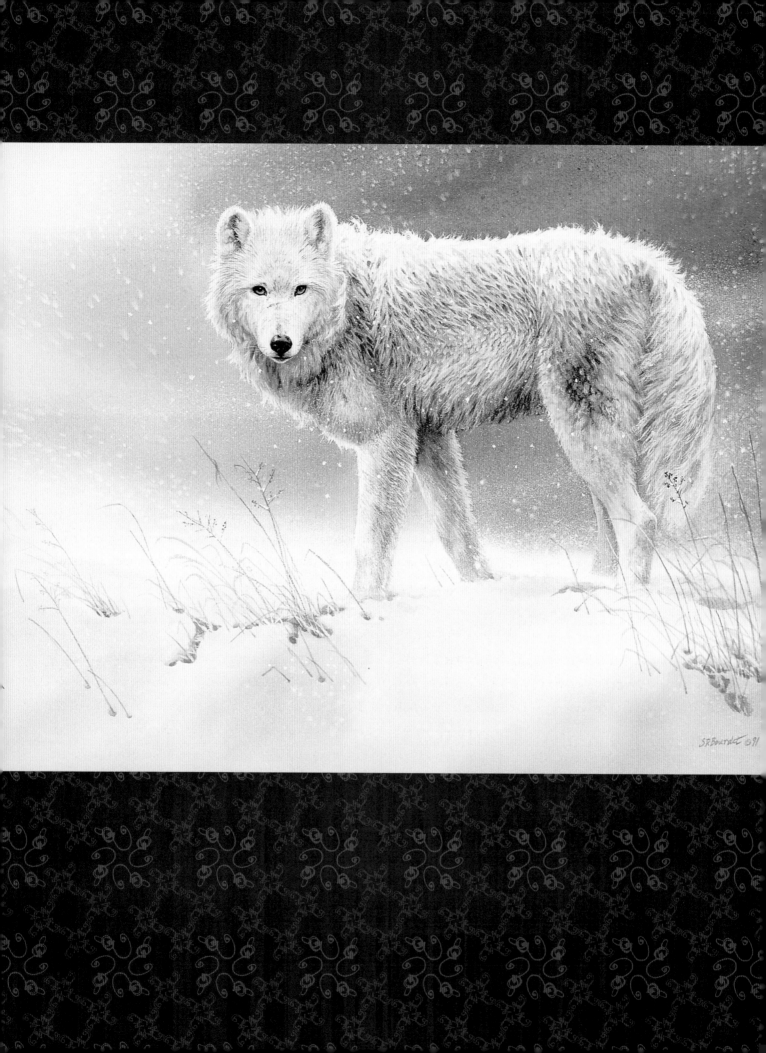

Introduction

A painting is a form of creative communication, just like a song or a story. How much it has to say is up to you, the artist. A song or story has an advantage: it is able to unfold, page by page or line by line, and reveal itself over time. A painting is there in front of the viewer all at once. Yet I've seen paintings that carry me away as well as a great story or stick in my head like an unforgettable melody. I'm sure you have, too. The question is: How can we make our own work this rich and memorable?

Maybe the secret is in looking closely enough to capture a subject's essence, not just describe its appearance. I've been told that if you "paint from the heart," others will see and respond to your passion. If only it could be so easy, right? If an artist thinks only about the physical shape of the subject in the creation of a painting, the resulting artwork will be like a simple, factual narrative without believable characters or descriptive passages. Like a story, a painting needs to have character development and a sense of time and place. So how does an artist, equipped with just two dimensions, make a painting that has layers of interest and really captures its audience?

With this book, I set out to find an answer to that question. I discovered that in painting nature, we can create a sense of time in the most basic of ways: by using light. As the earth spins on its axis and revolves around the sun, we have changing light and seasons to tell us where we are in time. Better than a song or story can, we can use this timekeeper—light—to our advantage. We can make a painting that tells the viewer the time of day with the angle of the light and the placement of the shadows. Not only can we "capture time" this way, but we can involve the senses. Sunlight can be warm and mellow or cool and wintry; it can suggest a physical feeling of temperature; and it can convey an emotional feeling of happiness or sadness.

Color, form and texture are the tools we use in our paintings to "develop character." We're all familiar with these tools, but in order to take our work to a richer level, we need to consider how color, form and texture are revealed by light. This sounds pretty simple—indeed, it sounded simple enough to me when I set out to write this book. But what I discovered as I went along is that it's not so simple. Light just isn't something you can easily "cook up" in your paintings. It doesn't wrap around your subject in predictable ways. It does all kinds of strange things that I hadn't really noticed until I began to look at my paintings as paintings of light, not paintings of objects. Light transforms every color in both value and temperature. It makes every texture more or less dimensional. It describes every form and gives it volume. Suddenly I realized how complicated this whole subject is!

In this book, I'll share my paintings and my efforts to make them richer by filling them with light. I feel pretty good about some of these efforts, while others just didn't turn out the way I had hoped. The greatest thing I have learned is that painting is a lifelong joy and a lifelong pursuit. No wonder the old masters painted until they could no longer hold a brush! The possibilities are endless; the actual process of painting is constantly challenging and an experience rich beyond belief.

Susan Bourdet

WHITE ON WHITE
Arctic Wolf
Watercolor on 300-lb. (640gsm) Arches cold-pressed paper
22" x 30" (56cm x 76cm)

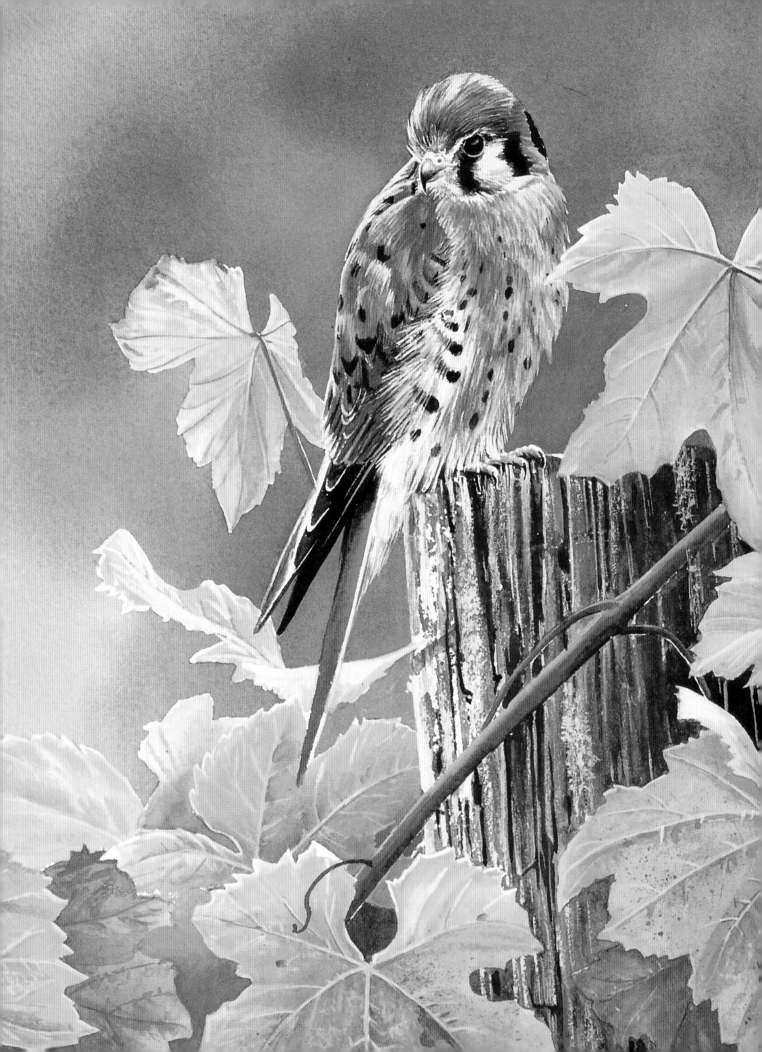

1

GETTING STARTED

*E*very artist has a slightly different way of doing things, so every artist has his or her favorite paints and supplies. The materials shown in this chapter are the ones I like to use. Try various brands and use what works best for the way you paint. If you're just beginning to purchase your supplies, buy the best materials you can afford. Quality supplies will last longer and give better results.

This chapter will show you how to improve your paintings by understanding and becoming comfortable with the properties of watercolors. We'll work toward a good understanding of the basics of color, how colors mix and how they work in a painting. You'll learn to create various types of color, from brilliant hues to subtle tones and shades. We'll also explore the value and temperature of color—aspects of color essential for painting light.

HARVEST GOLD (DETAIL)
Kestrel
Watercolor on 300-lb. (640gsm) Arches cold-pressed paper
14" x 35" (36cm x 89cm)
Published as a limited edition by Wild Wings in 2004

Paper

Choosing Your Paper

Of all the materials you purchase, paper has the most effect on your final product. Choices include:

Hot-pressed paper. The smoothest watercolor paper, this is great for details but not for large washes because there are no dimples to hold the paint.

Rough. The heavy texture is okay for washes, but is not so easy to paint details on.

Cold-pressed. This paper, which falls between hot-pressed and rough in terms of roughness, is just right. The 140-lb. (300gsm) weight will warp if you use lots of water. The 300-lb. (640gsm) weight is less prone to warping and is also more absorbent, meaning I can apply multiple washes without much lifting of the underlying color.

Inexpensive papers sold in a pad or block. I don't recommend these because they are often not acid-free, they can't take much water without disintegrating, and they warp badly.

Stretching Paper

The best board to stretch your paper on is Gator Board, a lightweight, washable, unwarpable, reusable board available at most art supply stores and from mail-order catalogs.

I don't stretch 300-lb. (640gsm) cold-pressed paper unless a painting is very large. I minimize warping by building up my washes and drying them completely between coats. I place my paper on an old bath towel while I'm painting to absorb water from the edges and prevent runbacks.

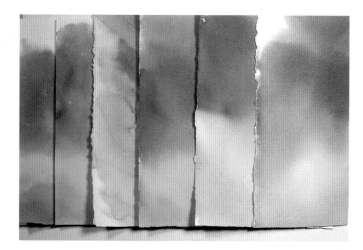

A Variety of Papers
Here are various papers with washes painted on them. From left to right: two inexpensive sheets (note the dullness of these washes); Arches 90-lb. (190gsm) rough; Arches 140-lb. (300gsm) hot-pressed; Arches 140-lb. (300gsm) cold-pressed; and Arches 300-lb. (640gsm) cold-pressed.

How to Stretch Watercolor Paper

1 WET THE PAPER, THEN STAPLE

Thoroughly wet the paper by soaking it for about five minutes in a bathtub or basin. Remove the paper from the water, then use a staple gun to staple the edges to the board, setting the staples in ⅜" (10mm) to ½" (12mm).

2 TAPE THE EDGES AND LET DRY

After the wet sheen is gone from the paper, tape the edges with packing tape to keep the staples from pulling out. Let dry flat.

How to Flatten a Warped Painting

If there is some warping of the final painting, place it on a flat surface, face down on a sheet of rag paper. Mist the back side very lightly, then place another rag sheet on top. Weight it for a day or so with heavy books. The painting will be flat at the end of this process.

Other Materials

Brushes

I like high-quality white artificial sables for their slight spring and good carrying capacity. A nice wide sable or artificial sable is good for backgrounds. A few stiffer oil-painting brushes are useful for lifting out color to create highlights in a sunlit scene.

Palettes

The most important feature in a palette is a large mixing area. Lots of deep wells are also useful. You can let the colors dry in the wells and moisten them each day before you start to paint. A white enameled butcher tray is handy as an extra mixing area.

Your Work Area

Good light is very important; if you don't have adequate natural light, get some moveable fixtures with color-corrected bulbs. Called "full spectrum" lights, they emit more warm wavelengths and resemble sunlight. You can find them at lighting stores and home improvement centers.

Other Useful Materials

- Masking fluid, yellow-tinted
- Masking pen
- White gouache for fine details
- Old or inexpensive round brushes, nos. 2, 4 and 6, for applying masking fluid
- Spray bottle with a gentle spray
- Paper towels
- Soft, absorbent rags
- No. 2 pencils
- Art gum or soft plastic eraser
- Tracing paper
- Sketchbook
- Hair dryer
- Workable fixative

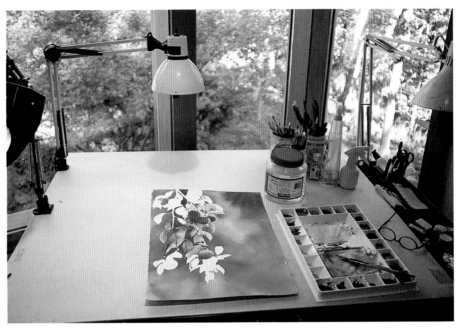

My Work Area
My art table faces north, so I get plenty of light without direct sunlight falling on the artwork. I also have several task lights with full-spectrum bulbs for working at night.

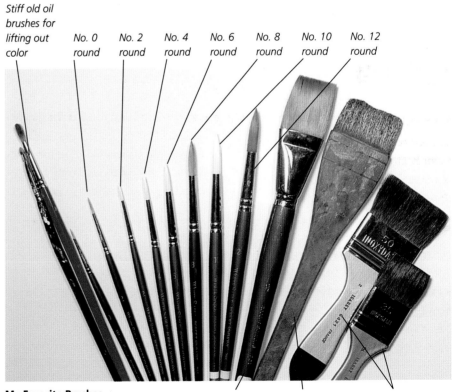

Stiff old oil brushes for lifting out color *No. 0 round* *No. 2 round* *No. 4 round* *No. 6 round* *No. 8 round* *No. 10 round* *No. 12 round*

White sable wash brush *Good old Chinese hake brush* *Wide sable wash brushes*

My Favorite Brushes
Because I paint lots of complicated curved shapes, I have a large selection of round brushes. For washes, my favorite brush is a very worn, inexpensive 2-inch (51mm) Chinese hake. It took about two years of use for it to become just right.

Paints

Color choices are part of the individual style each artist brings to painting. Without variations, art would become boring. Choose a good, well-tested professional brand rather than a cheaper, student-quality paint. Ultimately, the better-quality paints will save you money because they contain more pigment and less filler.

Here you can see the way I order my colors with the analogous groups together for easy mixing. I love the brilliance and transparency of Holbein colors, especially for painting flowers and botanical subjects. (All the colors on this page are Holbein.) For highlights and fur details, I sometimes use white Designer's Gouache (Winsor & Newton) or bleedproof white. Experiment with various brands to see what works best for the subjects you like to paint.

If you're just getting started with painting and don't want to have all of these colors on hand at the outset, a minimum "starter" set would be Permanent Yellow Lemon, Burnt Sienna, Permanent Red, Cobalt Blue, Compose Green #3 and Payne's Gray. With these you can mix a good variety of other colors.

Some of the brilliant and highly durable pigments are toxic, so please wash your hands, keep your brushes out of your mouth, and cover your paint water to keep pets from drinking it. Good brands will usually put a health warning on pigments that may be toxic; handle those colors with special care.

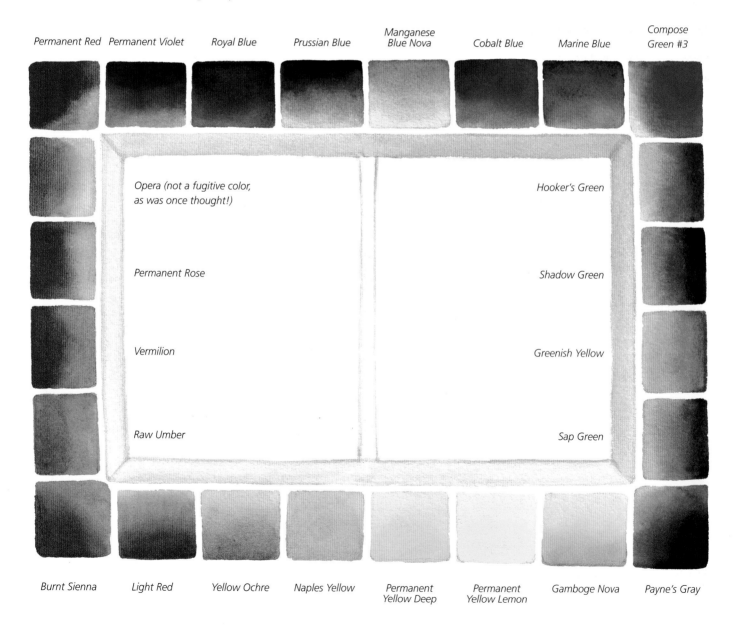

Permanent Red Permanent Violet Royal Blue Prussian Blue Manganese Blue Nova Cobalt Blue Marine Blue Compose Green #3

Opera (not a fugitive color, as was once thought!)

Hooker's Green

Permanent Rose

Shadow Green

Vermilion

Greenish Yellow

Raw Umber

Sap Green

Burnt Sienna Light Red Yellow Ochre Naples Yellow Permanent Yellow Deep Permanent Yellow Lemon Gamboge Nova Payne's Gray

Light and Color Essentials

A painting that glows with light has more impact than one with flat lighting. Before you "light up" your artwork, there are some essential color principles to understand. These principles will help you create believable shapes and give depth to your work.

Hue, Value and Intensity

Every color has three properties:

Hue: What we commonly refer to as "color." For example, a leaf painted with Hooker's Green has a green hue.

Value: The lightness or darkness of a color.

Intensity: The amount of brightness or saturation a color has.

The Value Chart on this page shows four hues: yellow (Permanent Yellow Deep), red (Permanent Red), pink (Opera) and blue (Marine Blue). These paints are the most vivid colors on my palette. Each one is shown in light, medium and dark values.

Squint at the chart's overall design and notice which colors "pop" forward. It may surprise you to see that some colors are most intense at their medium value rather than at their darkest value. That's because value and intensity are not the same thing.

Understanding a color's intensity is important when you're working with vivid colors. If you want an object or area in your painting to really stand out, you'll need to know what value of a particular color will produce the highest intensity and therefore the greatest impact.

Warm and Cool Colors

Colors in the red, orange and yellow range are warm, while those in the blue, green and violet range are cool. Additionally, there are relative degrees of temperature within a color family: some yellows, for example, are warmer than other yellows. As you paint light, you'll notice that warm colors appear to advance while cool ones appear to recede.

In the Color Temperature Chart on this page, the colors in the top row look warm because they contain more red or yellow, while those in the bottom row contain more blue and look cooler. Even though the hues are very similar, you can see the tendency of the cool colors to recede.

Permanent Yellow Deep *Permanent Red*

Opera *Marine Blue*

Value Chart
Shown are four tube colors, progressively diluted. Notice that intensity is not the same thing as value. The darkest values of Permanent Red and Marine Blue seem to recede; the darkest value of these colors is actually of lower intensity than their medium values.

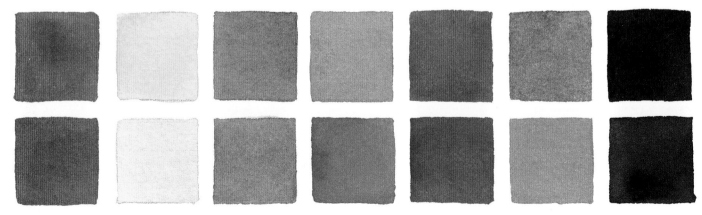

Color Temperature Chart
Warm colors (the top row) seem to come forward, while cool colors (the bottom row) recede.

Tints, Tones and Shades

Believable shadows are essential for a good painting. Shadows create the illusion of form. They are even more vital to the painter of light: to depict light, one must paint shadows.

When mixing colors for shadows, remember that shadows are not just darker versions of one color. Shadows contain many variations of color. You create these variations by mixing tints, tones and shades.

Tint: A lighter value of a color. Oil or acrylic painters create tints by adding white. Watercolorists create tints by diluting a color so more of the white paper shows through.

Tone: Created by adding gray to a color, which "tones it down" to create a duller hue. The darker the gray, the darker the resulting value will be.

Shade: Created by adding black to a color. There are black watercolor pigments, but they are likely to make your work muddy. Instead, I mix a black using two transparent darks: Payne's Gray and Burnt Sienna. The Grays and Browns Chart on this page shows the wide variety of shades you can create using just these two colors.

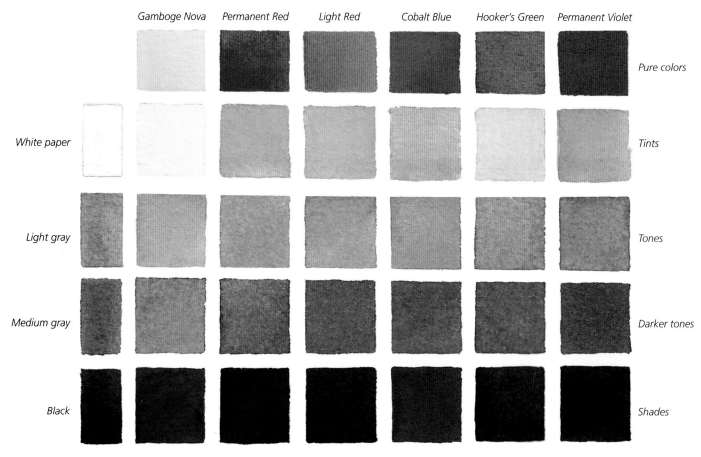

Gamboge Nova *Permanent Red* *Light Red* *Cobalt Blue* *Hooker's Green* *Permanent Violet*

Pure colors

White paper — *Tints*

Light gray — *Tones*

Medium gray — *Darker tones*

Black — *Shades*

Tints, Tones and Shades
The top row of this chart has six pure colors. In the second row are tints of those colors created by diluting the color to let more white paper show through. In the third and fourth rows are tones, created by adding grays (in this case diluted neutral mixes of Payne's Gray and Burnt Sienna). In the last row are shades, created by adding black (a dark neutral mix of Payne's Gray and Burnt Sienna).

Grays and Browns
Here are a few of the many grays and browns you can mix with the combination of Payne's Gray and Burnt Sienna.

Color Temperature

Besides changing the value of a color to create tones and shades, you can also introduce another range of subtle variation by changing the temperature of the gray or black you use to create the tone or shade. If you mix a tone by adding a cool gray, for instance, the resulting color will be cooler. These differences can be very slight yet still make a difference in your painting.

In general, cool colors appear to recede and warm ones appear to come forward. This effect is less pronounced with a tone or shade than with a pure color, but the effect is still noticeable. Also, even though the tones are duller and the shades are darker than the original colors, tones and shades made with transparent colors (such as Hooker's Green, Permanent Rose and Marine Blue in the

chart on this page) remain fairly luminous. Likewise, tones and shades mixed with opaque colors (such as Naples Yellow and Compose Green #3 in the chart) are more opaque than transparent mixes.

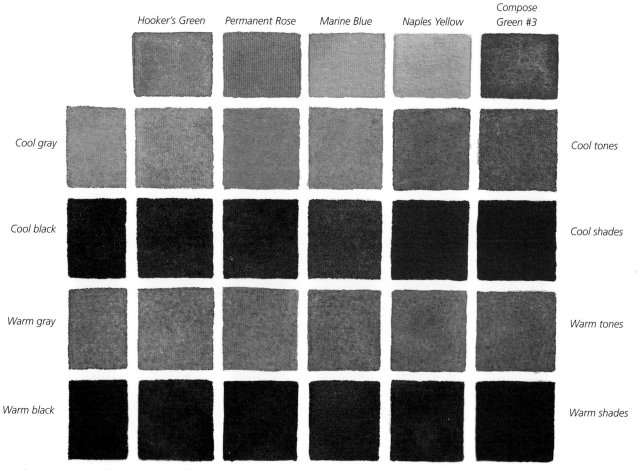

Warm and Cool Tones and Shades
The pure colors in the top row are mixed first with cool blacks and grays, then with warm blacks and grays. The resulting tints and tones retain characteristics of the original colors.

Basic Properties of Watercolors

When you introduce dramatic light to your paintings, you'll be doing lots of mixing to show how color is transformed by light. It helps to understand the color properties manufacturers mark on their tubes.

Permanence

Try to choose colors that are rated "durable" or "permanent" on the manufacturer's chart so your paintings won't fade. Some of the less-permanent colors, though, are hard to resist (such as Opera, a pink like no other!). If you use less-permanent colors, be sure to frame your painting behind conservation glass to prevent fading.

Opacity

Some pigments are much more transparent than others. Some tips:

- Transparent colors mixed together generally give a transparent result.

- Semitransparent colors can be mixed with transparents but should be used carefully, as the mixtures can turn muddy.

- Opaque colors blend with most other colors to create opaque mixtures. I use them only occasionally.

Properties of a Granulating Color
At left is Manganese Blue Nova, a granulating color. Following, from left to right, are Manganese Blue Nova mixed with: Burnt Sienna, Yellow Ochre, Light Red and Raw Umber. The wonderful effects possible with granulating combinations will be part of our study of texture on page 90.

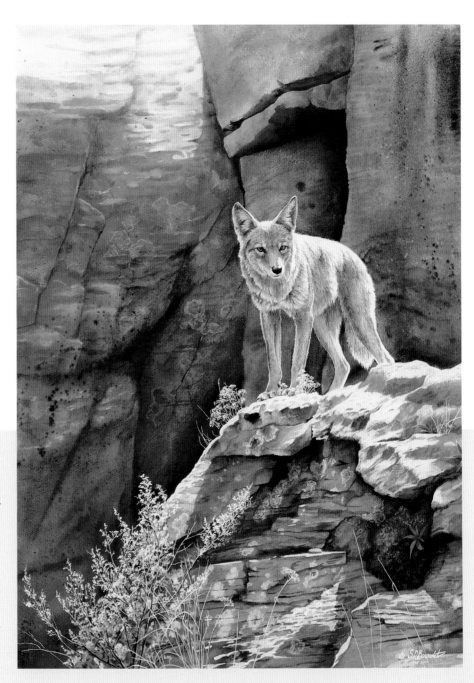

Granulating Colors Excel at Creating Texture
This painting was done in sedimentary earth tones—Burnt Sienna, Yellow Ochre, Light Red and Raw Umber. The shadows were created by mixing these pigments with another color that tends to granulate in a wash: Cobalt Blue. The result is an interesting grainy texture that mimics the appearance of sandstone.

RED ROCK CANYON
Watercolor on 300-lb. (640gsm) Arches cold-pressed paper
21" x 29" (53cm x 74cm)

Staining

Intense colors that tend to stain the paper may overpower other colors in mixtures—not a problem as long as you know what to expect. For example, in the Color Properties Chart below, you can see that Permanent Red didn't lift out much and left a stain. Add Permanent Red to mixtures a little at a time. Also be sure to save your highlights because they can't be lifted out of Permanent Red. Some other "stainers" on my palette are Cobalt Blue and Permanent Yellow Lemon.

Granulation

Some colors are granulating, meaning the pigment settles out and gives a grainy appearance. Granulating colors are useful for creating texture but can detract when you want a smooth wash.

Color Properties Chart

I made the chart below as a reference for the colors on my palette. The chart demonstrates several vital characteristics of each color. I encourage you to make a color chart like this one for the colors on your palette. Keep your chart handy and refer to it as you paint.

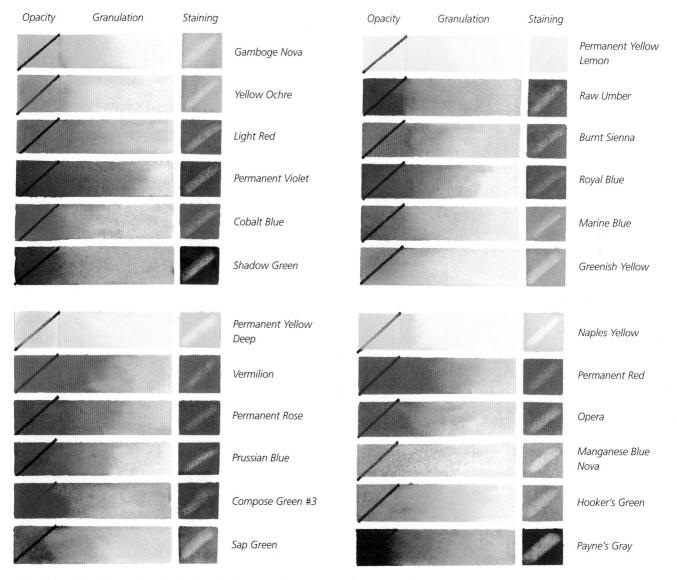

Color Properties Chart

Opacity. Full-intensity color is painted over a line of black indelible ink. Opacity is indicated by how well the paint hides the line.

Granulation. Each color is progressively diluted. This shows whether the color granulates, as well as how smoothly it flows and how intense it is.

Staining. Each color is painted at high concentration, dried, then scrubbed with a stiff damp brush and blotted with a paper towel. The lifted area shows whether the color stains.

Three Ways to Mix Colors

Mixing on the Palette

The most common way of color mixing is to mix a color on your palette, then apply it to the painting. This way gives you the most control over the result.

Mixing Wet-Into-Wet

To mix wet-into-wet, apply some water to the paper, then lay in colors, tilting the paper a little to allow the pigments to run together. This effect is spontaneous, fresh and flowing. The amount of blending will depend on how much water you use and how concentrated the pigments are. You have less control with this method, so it is best suited for larger areas.

Glazing

Since many watercolor pigments are transparent, glazing is a wonderful way to "mix" color on the paper. First lay in an initial wash, usually a fairly pale one, then dry that wash completely. This establishes a base. Lay in a second wash gently over the first and let it dry. By drying each coat thoroughly before adding another, you can have multiple layers of pigment, gradually deepening or changing the color like stacked sheets of stained glass. The essential thing to remember is that you must completely dry the underlying wash before adding another layer.

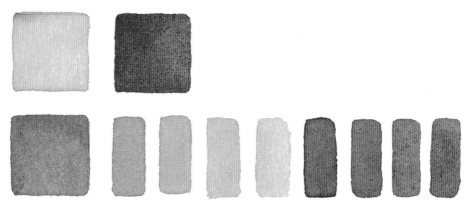

Mixing on the Palette
Here are mixtures of Gamboge Nova and Opera. The orange is the result of a 50/50 mix of the two colors. The smaller rectangles are just a few of the many hues possible when you vary the percentages.

Mixing Wet-Into-Wet
Here are all of the warm colors on my palette blended together with the wet-into-wet method of letting the colors mix on the paper. Mixing color wet-into-wet produces some of the most magical effects in watercolor.

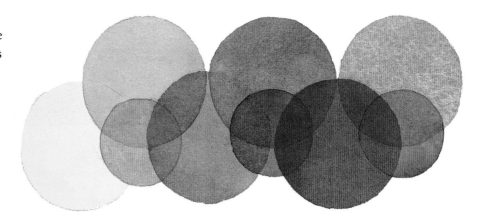

Glazing
Like layers of stained glass, transparent colors can be built up with glazes. Glazing is a wonderful way to build up color while maintaining transparency. You'll get the best results with the most transparent pigments.

Mixing Neutrals

Unwanted Neutrals, or "Mud"

When complementary hues (those across from each other on the color wheel) are mixed, the result is a muddy neutral. Some of the most common reasons that artists end up with a muddy painting (reasons I learned the hard way!) are:

- **Not planning the color scheme before starting to paint.** The variety of colors in nature is overwhelming. If you try to paint them all, it's impossible to unify your painting. Instead, mix tints, tones and shades of a few chosen colors.

- **A dirty palette.** It's not enough just to clean the mixing area; if the pigments in the wells are polluted with other colors, your mixes don't stand a chance.

- **Too many colors in mixtures or glazes.** Mixtures of two colors work best; three can work if they are adjacent on the color wheel.

- **Mixing complementary colors.** This only creates tones of olive, gray and brown. Some of these muted tones are beautiful and useful, but some are downright yucky!

How to Mix Neutrals When You Want Them

Neutral colors are essential in nature paintings: they are the colors of earth, rock, tree bark and even well-camouflaged animals. A mixed neutral is more interesting than a tube neutral, and if you mix two colors that are part of your color scheme, they can help unify your painting.

Some complementary mixtures work better than others. For instance, Permanent Red mixed with Hooker's Green makes a dull olive, but mixing Hooker's Green with a near-complement like Permanent Rose creates an attractive gray.

When mixing a neutral, do so on the palette first and test it on scrap paper.

Permanent Red + Hooker's Green

Permanent Red + Shadow Green

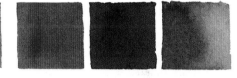

Permanent Rose + Hooker's Green

Light Red + Sap Green

Permanent Violet + Gamboge Nova

Permanent Violet + Burnt Sienna

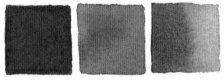

Royal Blue + Light Red

Cobalt Blue + Yellow Ochre

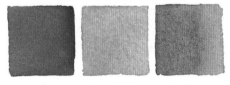

Vermilion + Marine Blue

Light Red + Marine Blue

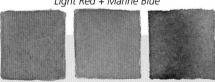

Neutrals From Complementary Mixtures
Complementary color mixes will give you a range of browns and grays. If that's what you want, great! But watch out for them if you're striving for bright, glowing color.

Tips for Luminous Mixtures

- Choose a color scheme before you start to paint, limiting the number of colors for a more cohesive result.
- Try possible color combinations on scrap paper before you start to paint.
- Keep your palette and water clean.
- Mix only transparent colors, or mix one opaque with one transparent color from the same side of the color wheel.
- Mix complementary colors only if you want browns and grays.
- Glaze with transparent pigments, never opaque ones.
- When glazing, dry each coat thoroughly.
- Avoid granulating colors when you want a smooth mix.

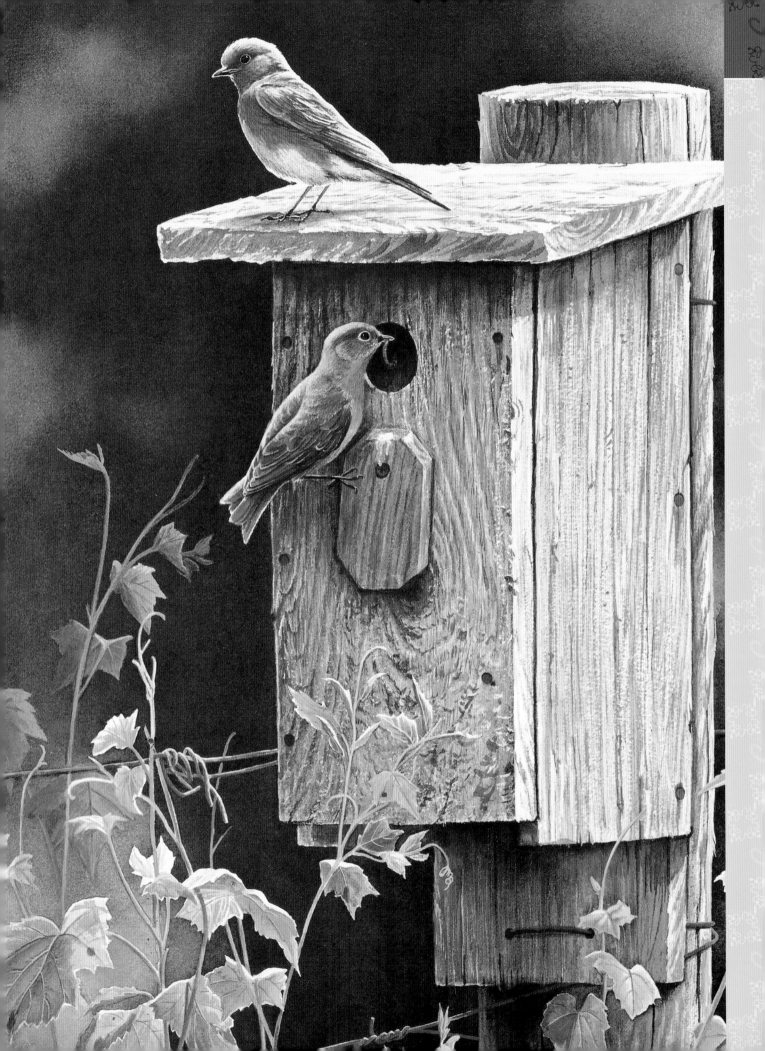

2 INSPIRATION, DOCUMENTATION AND DESIGN

What makes a painting interesting enough to earn more than a passing glance from the viewer? After twenty-five years of making art, I've learned that a really fine piece is more than careful craftsmanship and an interesting subject. For a painting to really sing, it needs to express what captivates you about your subject. That begins with capturing your very own idea and continues with creating a well-designed composition. This chapter will teach you how to take good reference photographs and how to shape reference material into an appealing and effective design.

NEW BEGINNINGS (DETAIL)
Eastern Bluebirds
Watercolor on 300-lb. (640gsm) Arches cold-pressed paper
29" x 20" (74cm x 51cm)

Approaching Reference Photography

Nature doesn't stand still for anyone. So a 35mm camera, or the newer digital kind if you prefer, is an important tool. Taking a reference photo isn't the same as taking a good photograph. A reference photo should do a good job of capturing one thing: the texture of a weathered fence post, say, or the pose of a bird. In the studio, you can combine elements from different photos to create a great composition.

Build a File of References

Organize your reference photos by subject, either on your computer or in an old-fashioned file cabinet. My file, accumulated over many years, contains thousands of photos of birds, animals and settings. As your file grows, you'll be able to pull photos from it that have just the right subject, or maybe the right branch, backlit leaf or fence post to make a composition work.

What to Look For When Photographing References

If you head out the door looking for a certain subject, you will probably walk right past all kinds of great stuff. Instead, look for these three essential building blocks of an exciting painting:

Light: Some things in a painting you can ad-lib, but light has to be observed in real life for it to look right in your artwork. Move around your subject to find the most interesting lighting. The best times of day to photograph are when the light comes from a low angle, in the early morning or late afternoon. Photographers call low-angled light "the sweet light" because shadows are rich, colorful and enlivened with reflected light. Animals are more active in the morning and evening, too.

Color: As you photograph, look for breathtaking color. Color is transformed by light from its basic hue to an amazing array of tints, tones and shades. Let yourself be inspired by color!

Texture: Photograph all kinds of textured objects in great light, from garden equipment and fence posts to flowers, butterflies and tree bark. Notice that textures are amplified by light.

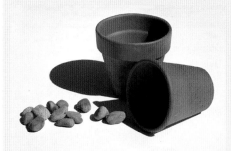

Midday Light
Midday light with the sun directly overhead creates short, dark shadows and little or no reflected light. The resulting photos have too much contrast and not enough detail.

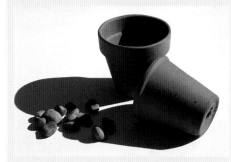

Early Morning Light
In the early morning, shadows are lighter and bluer. The details in the flowerpots and stones are more visible. As a bonus, the low-angled light bounces up from the surface and illuminates the darkest areas of the flowerpots.

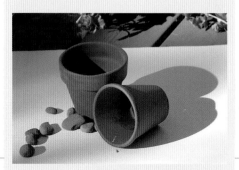

Late Afternoon Light
As with the morning light, the sun is at a low angle, lengthening and enriching the shadows.

Supplies to Carry When Taking Photographs

- A single-lens reflex (SLR) camera. You need an SLR camera to compose photos accurately.
- Zoom lens. A 75mm–300mm zoom is versatile enough to use for both close-up subjects and distant ones.
- Camera bag. A bag with a waist strap keeps your hands and arms free.
- Tripod
- Sketchbook and drawing materials
- Binoculars
- Extra rolls of film or extra storage cards for a digital camera
- Extra camera batteries
- Pocketed vest
- Pocket-size field guides

24

Do's and Don'ts for Reference Photos

Don't: Under- or Overexpose
Poorly exposed photos make it hard to see form and detail.

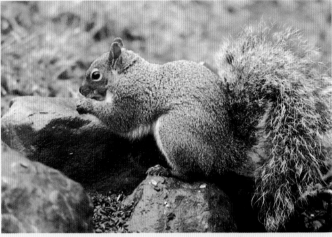

Do: Bracket to Get a Good Exposure
Study your camera manual to learn the basics of good exposure. To be sure you get the shot, "bracket" your exposures: Take a shot at the camera's recommended aperture setting, then take another shot one f-stop over the recommended setting and another shot one f-stop under.

Do: Photograph Your Subject at Eye Level
Crouch down to photograph objects or animals on the ground. For birds, try hanging a feeder at window level.

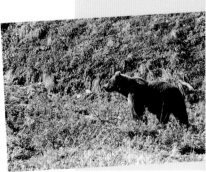

Don't: Shoot Down or Up at Your Subject
These perspectives will be hard to use in a painting.

Do: Photograph Against an Uncluttered Background
Try to photograph against a background that contrasts with your subject so that you can see the subject clearly.

Don't: Photograph on a Busy Background
This makes your subject hard to see clearly and also can make focusing more difficult, especially with auto-focus cameras.

Places to Photograph Wildlife

Taking your own reference photos gives you ownership of your idea from start to finish. If you like to paint birds and small animals, you must actively seek out subjects. Photographing wild animals in their own element can be a challenge. It's easier to photograph them in settings where they are accustomed to people, such as backyards, public gardens, zoos and parks.

Look in Your Backyard

Ask your local Audubon Society or nature shop for advice on setting up feeders and a water source in your backyard. I added a waterfall and pond to my backyard, and many kinds of creatures have been attracted to it: chipmunks, squirrels, dragonflies, butterflies, frogs, lizards, songbirds, quail, wild turkeys, raptors, raccoons, deer and even a skunk. Our neighbor's larger pond even attracts herons and ducks! Whether you choose a small pool, a pond, a fountain or a birdbath, be sure to include the sound of trickling or running water. You'll soon have easy-to-photograph subjects close at hand.

Try setting up your tripod and camera near the feeder or pond and using a cable release shutter attachment to snap the pictures. This will allow you to operate the camera from a distance and avoid scaring off your subjects.

Birds in the Backyard
My backyard feeders attract all kinds of seedeaters. Add some suet to bring in woodpeckers like this red-breasted sapsucker, and don't forget to put up hummingbird feeders and birdhouses.

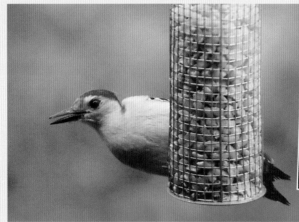

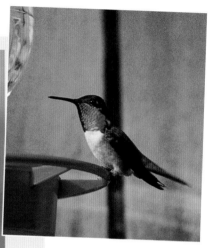

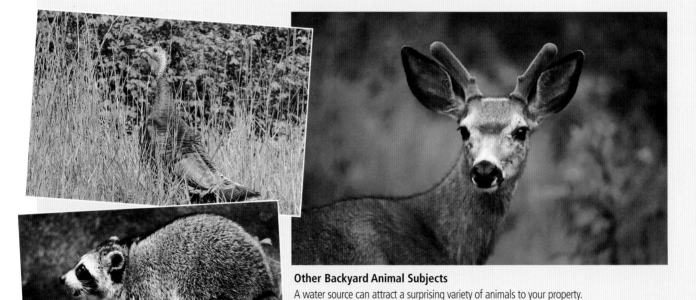

Other Backyard Animal Subjects
A water source can attract a surprising variety of animals to your property. Here are some of the visitors I've been able to photograph in my backyard.

Try Zoos or Wildlife Centers

Zoos and wildlife rehabilitation centers often keep birds and animals that are too injured or too accustomed to humans to be released into the wild. Since most wildlife centers are funded by donations, they are usually happy to let you sketch and photograph their animals for a small donation.

Rather than photographing animals in dark cages, try to find them out in the open where there is good light. Look for events where animals are brought to schools or other facilities to educate the public. You might, for example, find a "raptor show," where hawks and eagles are brought out on a handler's glove or flown around.

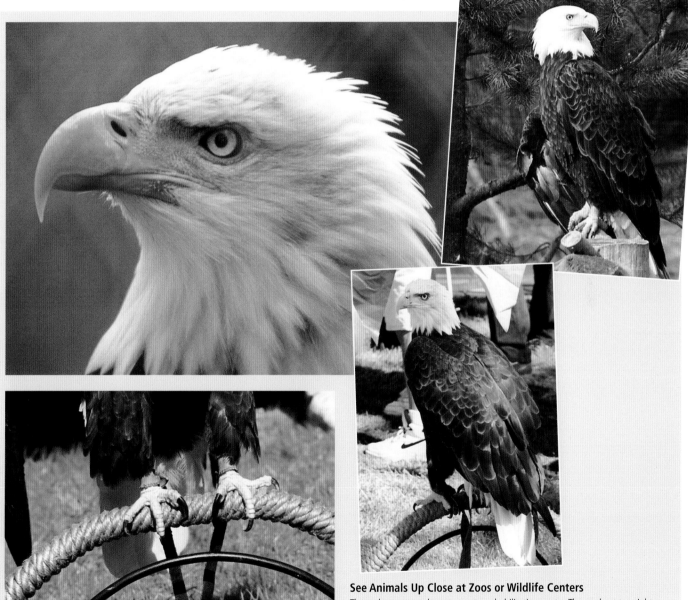

See Animals Up Close at Zoos or Wildlife Centers

These shots were taken at a raptor rehabilitation center. The eagle at top right has a broken wing, which would be hard to disguise in a painting, but the photo could be used as a reference for head position or feather texture. Don't forget to zoom in for those critical details. Most importantly, don't get carried away with the subject itself and forget to look for the best possible lighting.

Photographing Settings

Before you shoot a setting, ask yourself what about it catches your eye. Then take many photos from different angles. Look for interesting lighting. Think about where in the setting you would place your center of interest, and make sure you have close-ups of that area since that part of the painting will need the most detail.

Flowers and Leaves

You may be attracted to the overall effect of a mass of leaves or flowers. But if you stand back and snap a shot of the entire mass, you will end up with a jumbled photo that lacks detail. For a more useful reference, pick a small part of the scene with an interesting composition and good, clear contrast so you can focus easily.

Textures

Light reveals and enhances textures, so it's important to get a good exposure when photographing textures. Bracket your exposures by taking a shot at the camera's recommended aperture setting, then another shot one f-stop over the recommended setting and another shot one f-stop under. This way you can be quite sure of getting the shot.

Landscapes and Rocks

As you photograph settings, consider where you would place your subject. With rocks, for instance, you'd want to adjust your position to photograph the best perch for your bird or animal at eye level. Shoot a few overall shots of the setting, but then zoom in on the center of interest area so you'll have plenty of detail.

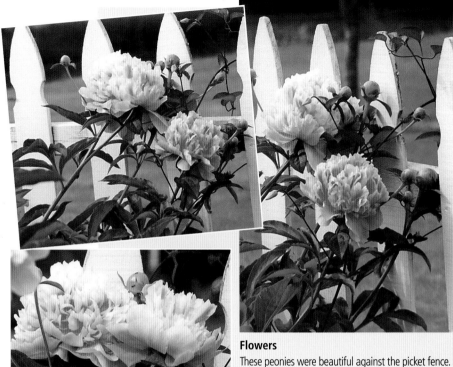

Flowers
These peonies were beautiful against the picket fence. I took both vertical and horizontal shots because I wasn't sure which way I'd paint them, and I made sure to get a good detail shot of the flowers. Here the light is soft but comes just enough from the upper left to cast slight shadows.

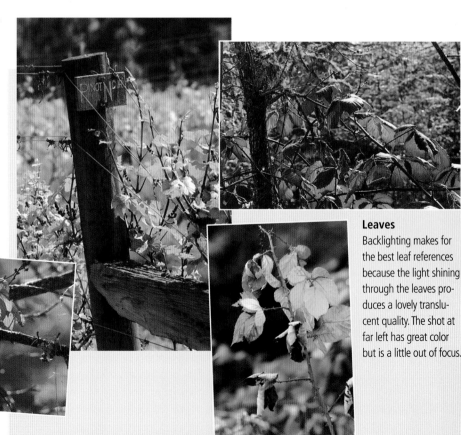

Leaves
Backlighting makes for the best leaf references because the light shining through the leaves produces a lovely translucent quality. The shot at far left has great color but is a little out of focus.

Textures

I love the textures in these subjects—the rough, irregular surface of old wood, the pebbly texture of rust.

The shot directly below, taken at midday, would be hard to use because the shaded side of the post is underexposed and nearly black. The solution for this would be to take two photos: one that exposes the front of the post and the leaves correctly, as I did here, and another photo using a wider aperture setting that will overexpose the front of the post but will expose the dark side of the post correctly. Many cameras have a spot metering feature to make this easier.

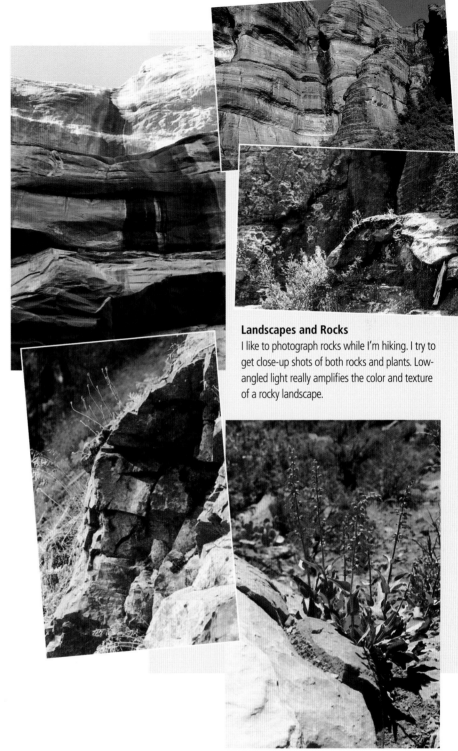

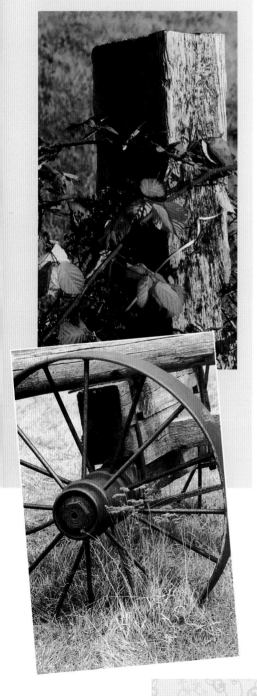

Landscapes and Rocks

I like to photograph rocks while I'm hiking. I try to get close-up shots of both rocks and plants. Low-angled light really amplifies the color and texture of a rocky landscape.

About Depth of Field

Depth of field is the range of distances that are in focus in a photograph. In a photo with high depth of field, everything from foreground to background is in focus. A photo with shallow depth of field may have a sharp foreground but an out-of-focus background.

Wide apertures and zoom lenses reduce depth of field; small apertures and wide-angle lenses increase it.

So, if you are shooting a scene for a painting in which the background will be in sharp focus, use a 50mm or 75mm lens and set the aperture as small as light conditions permit. As the aperture decreases, reducing the incoming light, the shutter speed must become slower to let in more light, so use a tripod to prevent blurring.

If you intend to paint a soft-focus background, your reference photo can have lower depth of field. Go ahead and use your zoom lens and a wide aperture.

Design Principles and Pointers

Placing the Center of Interest

Every painting needs a center of interest. This is the area where you want the lighting, color or texture to really shine. There are a couple of rules about locating the center of interest. You can always break them, but they can be helpful.

The Rule of Thirds: Imagine lines that divide your image into thirds both horizontally and vertically. The Rule of Thirds says that anywhere where the lines intersect is a good place to locate your center of interest.

The Magic X: Imagine an X connecting the corners of your picture space. Anywhere along the arms of the X—except where the lines cross—is a good location for the center of interest.

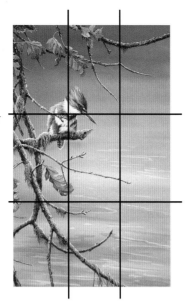

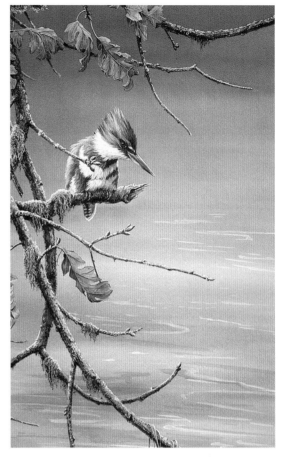

The Rule of Thirds
Grid lines divide this image into thirds. According to the Rule of Thirds, anywhere the lines intersect is a good place for the center of interest.

GONE FISHING
Kingfisher
Watercolor on 300-lb. (640gsm) Arches
 cold-pressed paper
29" x 14" (74cm x 36cm)

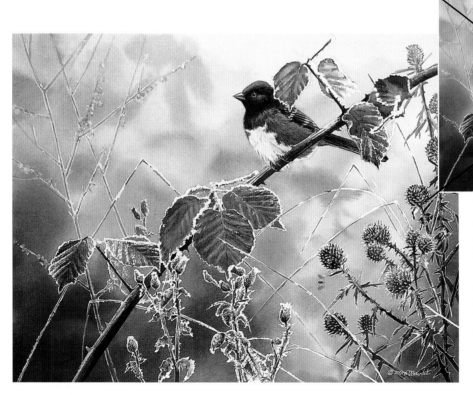

The Magic X
An X connects the corners of the picture space. The center of interest is located along one arm of the X, but not in the center.

NOVEMBER FROST
Towhee
Watercolor on 300-lb. (640gsm) Arches
 cold-pressed paper
13" x 16" (33cm x 41cm)

Move the Viewer's Eye Around the Composition

Place design elements so that they move the viewer's eye around the composition. Many objects, like tails, twigs, beaks and grasses, tend to direct the eye. So does the direction of a bird's or animal's glance. Directional elements need to be thought of as arrows and pointers in the design. Linear elements like branches or wires divide spaces and should be placed so they don't cut an area right down the middle.

You can use directional and line elements to your advantage to make your composition stronger. The goal is to make the viewer look not just at the center of interest, but to move his attention subtly around the general area of interest. A branch shooting out to a corner of the page, for instance, would pull the viewer's attention right out of the picture, while one that bends down or back toward the center of interest keeps the eye moving around in the picture.

Place large shapes in your design so they break up the spaces in a graceful, uncluttered way. Avoid shapes that suggest other objects. I once painted a floral piece with an unintended teddy bear shape in the center!

Also be conscious of design features that will tend to interrupt the movement of the viewer's eye:

- Avoid intersecting lines or objects that create an X in your design. The center of the X will draw the viewer's eye.

- Avoid placing a large round shape, such as a flower, at the center of the composition. Doing so can create a bull's-eye effect, even if the center of interest is elsewhere.

Don't Forget Quiet Spaces

Don't make your composition too busy; the eye needs rest areas.

Also consider the negative spaces—the spaces between and behind the shapes. While the compositional puzzle pieces you'll be assembling are realistic, remember to consider both positive and negative spaces as abstract shapes that should relate in an interesting way.

Have a "Hook" for Each Painting

What grabs you when you look at your references is what will grab your viewer. There isn't much point in doing a painting that has no point to it, right? The best compositional advice I can give is to remember that every painting needs to have something that sets it apart and makes it interesting—a "hook." Often, the secret is in your use of light, color or texture, those spectacular elements you've caught in your references.

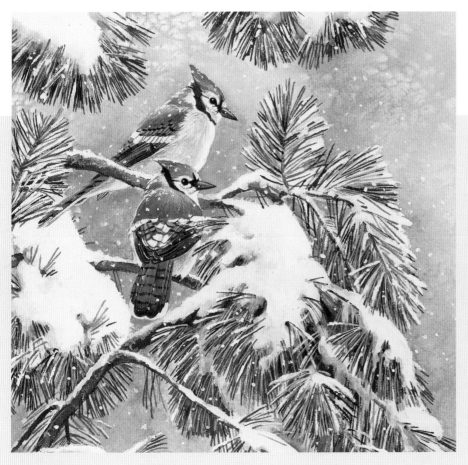

No Painter Is Perfect

It's hard to make a flawless composition. If we did, it might be too boring!

I did certain things right in this painting. The birds look into the painting, not out of it. The branches help move the viewer's eye in a roughly circular pattern around the design, and the snow shapes divide the negative space in an attractive way.

However, the three horizontal branches are too evenly spaced. The upper bird's tail tip should be behind the snow. The lower bird's tail points down into a V shape in the branches and draws the eye unnecessarily.

SNOW FLURRIES
Bluejays
Watercolor and gouache on 300-lb. (640gsm) Arches
cold-pressed paper
12" x 14" (30cm x 36cm)

Keep What Works, Adapt What Doesn't

In all my years of taking pictures, I have never gotten a reference that had everything I wanted in just the right place. Invariably, I have to reshape and reorganize my photographic materials. But it's exciting to create your very own concept using elements from various photos.

The critical thing is to make sure the light temperature and direction is consistent among the photos you combine. Often you'll have the right pose for your subject, but you'll need to change the light angle to match a setting. Sometimes I make a clay model of an animal subject and shine a light on it so I can see where the shadows should be.

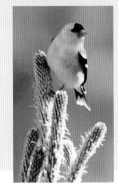

Upper Bird
The light was bright and came from a pleasing direction, but the green background turned the shadows on the bird gray-green. I knew I would have to alter the shadow colors to fit with the red-orange flowers.

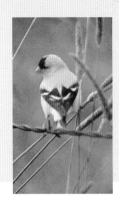

Lower Bird
This photo was taken on an overcast day, so I needed to brighten the light on the bird's head and upper right side and add a shadow to the bird's left.

Flowers
The botanical references are busy and contain more detail than would be needed in a painting.

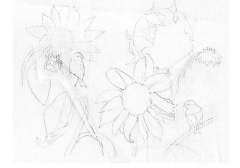

Tracing Paper Sketch
I drew design elements on tracing paper and moved them around until I was happy with the composition. The sunflowers are placed off-center. Simplifying the flower references provides areas for the eye to rest. The stems are directional elements that move the eye around the composition.

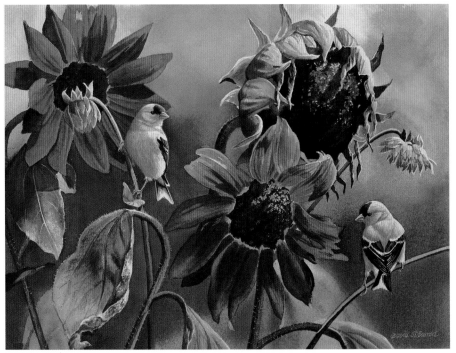

AUTUMN GOLD
Goldfinches
Watercolor on 300-lb. (640gsm) Arches cold-pressed paper
11" x 14" (28cm x 36cm)
Collection of Mrs. Della Greenfield

FROM PHOTOS TO PAINTING
Light Makes the Magic

Strong lighting adds warmth, interest and intensity to a composition. It also acts as a unifier, helping to pull the design together. You can use light to emphasize your center of interest and to delicately accentuate secondary interest areas.

I photographed this screech owl at a raptor center. He had been hit by a car and lost part of a wing. Later, as I studied the photo labeled Owl Photo 1, I was captivated by the owl's eyes, which show him to be a wild thing in spite of his loss of flight.

Owl Photo 2 is of the same owl, yet it just doesn't capture the look in his eyes. Why? This photo lacks dramatic lighting. Evidently the magic wasn't just in the owl's eyes; it was also in the light.

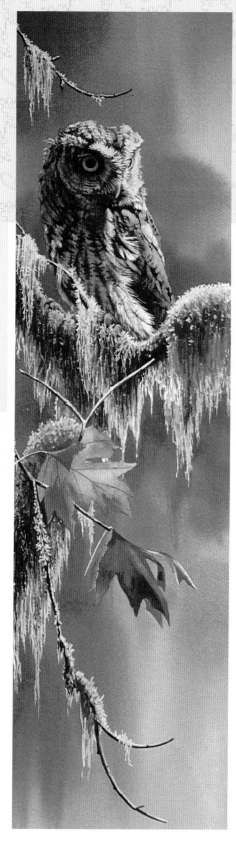

Setting
Upon returning to the studio, I looked through my file of reference photos to find a setting for the owl. I decided on a mossy branch with a few sunlit leaves to reinforce the idea of light.

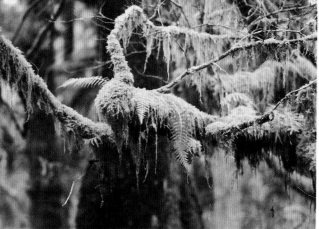

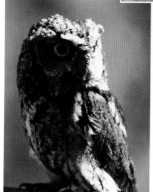

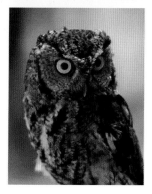

The finished painting is as much about light as it is about the screech owl.

OWL EYES
Screech Owl
Watercolor on 300-lb.
 (640gsm) Arches cold-
 pressed paper
22" x 8" (56cm x 20cm)

Owl Photo 1

Owl Photo 2

Color Adds Impact

A big part of your job as a painter is to observe and interpret how color is transformed by light. In the dark, your perception of color is reduced so you see shades of black and gray. In the sunlight, not only do you see the basic hues, but the many tints, tones and shades that define shapes. Color adds mood and feeling to your paintings. It is also a compositional tool, helping to tie a design together through repetition and harmony.

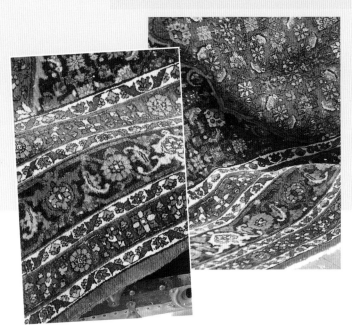

Carpet
Having a whole series of carpet reference photos helped me understand the complex patterns. I'm showing you only a few of them. I found it helpful to make copies of some of the photos and then tape them together to reconstruct the carpet.

Kitty
This cat was antsy and didn't want to sit still for a portrait. I ended up using a different cat (my own cat, Max) as a reference for the body.

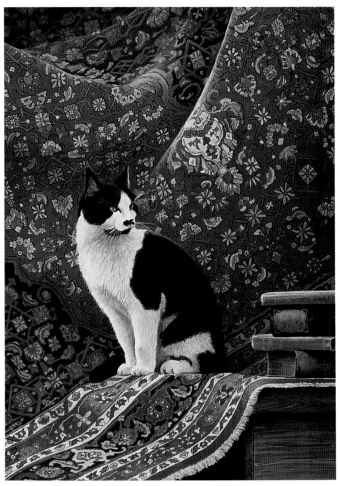

A Challenging Subject
The carpet has a complex pattern of vibrant colors which seems to change as the light plays over the folds. Capturing this was the most challenging aspect of the painting, especially since I had to work on the carpet area over a period of several weeks. I premixed all of the colors and kept them in baby food jars so that the colors would be consistent over the entire painting. Premixing works well for large, complex compositions like this one.

KITTY AND THE PERSIAN CARPET
Watercolor on 300-lb. (640gsm) Arches
 cold-pressed paper
30" x 22" (76cm x 56cm)

Texture Lends Interest

Texture takes the viewer beyond color, light and mood to an almost tactile experience. Light is the defining force: texture is revealed by the fact that light strikes the high points and shadows lie in the low points. Careful observation will help you understand and paint textures.

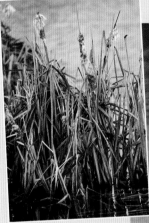

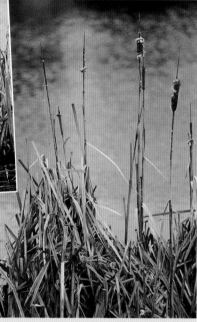

Reeds
I photographed these reeds on an overcast winter day. If it hadn't been for the high contrast that revealed the amazing textures in this clump of reeds, I'd have walked right past it. Overcast lighting can work if it is bright enough. Just make sure the light is consistent in both subject and setting.

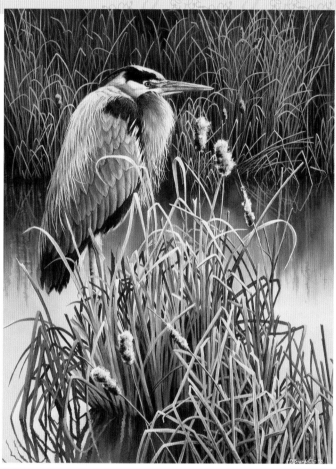

Heron
I photographed this heron on a very cold day at the coast. I wanted to paint him to show how perfectly adapted he was for his setting, with his feathers fluffed against the chill.

Subdued Color, High Contrast
With a subdued color scheme and soft lighting, the textures of reeds and feathers became the point of the painting. The greatest challenge of this painting was to give the complicated reeds a sense of depth. There was a risk of getting lost in the details. Since the light source was subdued, values proved to be the key.

The colors in the piece were soft browns and grays, so there wasn't a punch of color to give the painting impact. It looked weak until I used an almost black mixture of Payne's Gray for the black markings on the bird and then tied that dark with the crisp dark reflections. This created an interesting design for the eye to follow and gave the piece the punch it needed.

WINTER MARSH
Great Blue Heron
Watercolor on 300-lb. (640gsm) Arches cold-pressed paper
30" x 22" (76cm x 56cm)
Collection of Alan Prill

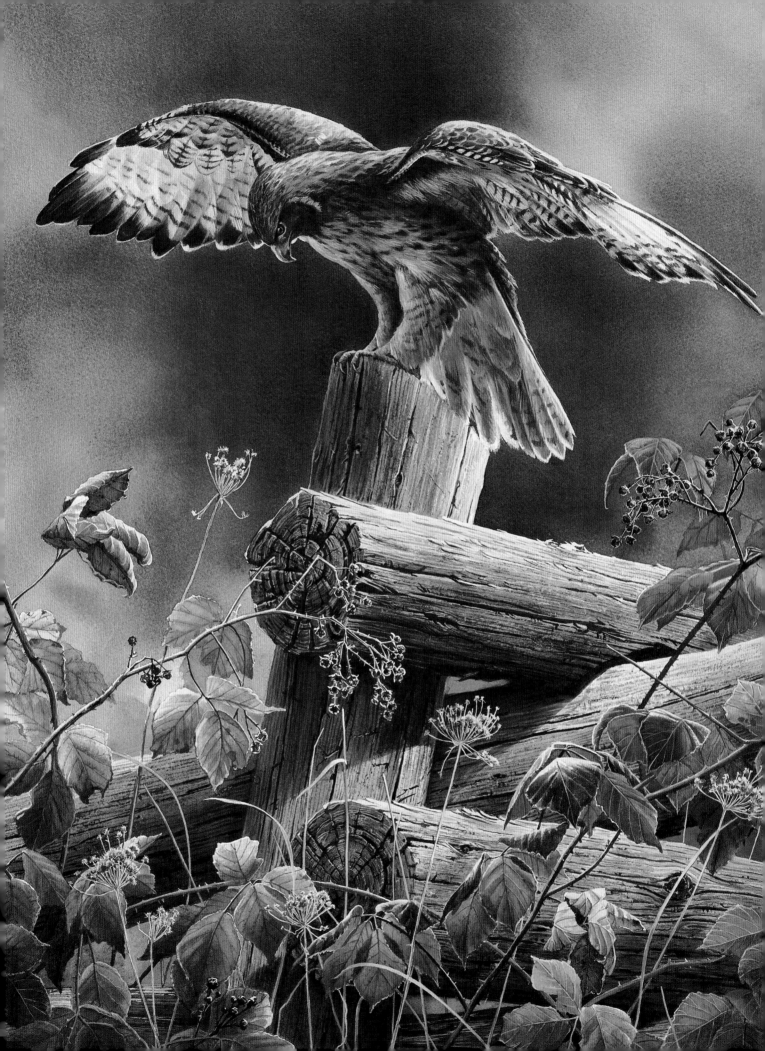

3 BASIC WATERCOLOR TECHNIQUES

*E*very time you begin a new painting, you are faced with a fearsome prospect—a completely blank sheet of paper! Knowing that particular fear firsthand, my focus in this chapter will be to help you equip yourself to face a pristine sheet of watercolor paper with anticipation instead of dread. The basic watercolor techniques are not really difficult. But one of the biggest challenges in watercolor painting is getting just the right amount of water on the paper, as well as mixed with the pigment, for each particular technique. If you can learn how much water to use in different circumstances, you will have come a very long way in learning to use this medium.

TOUCHDOWN
Red-Tailed Hawk
Watercolor on 300-lb. (640gsm) Arches cold-pressed paper
30" x 22" (76cm x 56cm)

MINI-DEMONSTRATION
A Dark Wet-Into-Wet Wash

Wet-into-wet means applying watercolor to wet paper. This method creates the soft blends for which watercolor is known and loved.

1 MIX YOUR COLORS
Mix puddles of the four colors on your palette, making them about the consistency of cream.

2 WET THE PAPER
Lay your cold-pressed paper smooth side up on an old towel. Wet the paper with the wash brush and clean water. When you look from a slight angle, you should see a nice even shine with no dry spots or puddles.

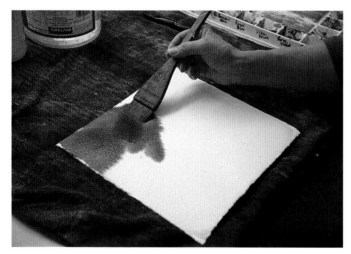

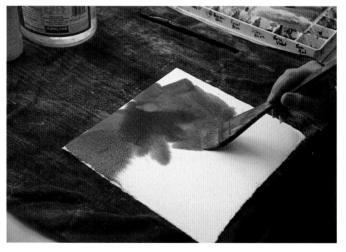

3 LAY IN THE FIRST COLOR
Blot the brush, then load it with plenty of Payne's Gray. Working quickly, brush the color into an upper corner of the paper, then pull it toward the center. Don't dab with a tentative stroke—flow color on with large, flat strokes for a smooth, even application. Reload and repeat as you wish, but be careful not to add too much water.

4 CHARGE IN ANOTHER COLOR
While the Payne's Gray is still shiny wet, rinse and blot the brush, then pick up some Compose Green #3, an opaque green, and work it right up into the gray. The colors will begin to blend. You are "charging" the gray with green.

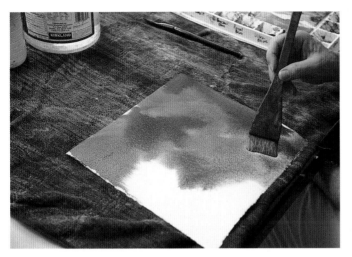

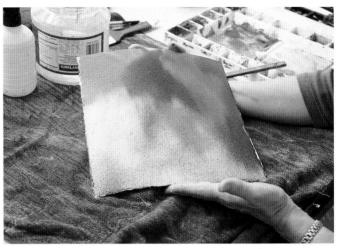

5 ADD LIGHTER COLORS
While the dark wash is still shiny wet, paint in some Greenish Yellow and some Quinacridone Gold.

6 BLEND THE COLORS, THEN DRY
While the wash is still wet, tilt the paper back and forth to blend the colors a little. Dry the wash with a hair dryer.

A Dark Background Done Wet-Into-Wet
Wet-into-wet is ideal for large areas and backgrounds because lots of color can be applied and blended very quickly. A wet-into-wet background sets off the subject without competing. This dark background was painted with a mixture of Payne's Gray and Compose Green.

CANDYSTRIPES
Rose-breasted Grosbeak
Watercolor on 300-lb. (640gsm) Arches
 cold-pressed paper
12" x 15" (30cm x 38cm)

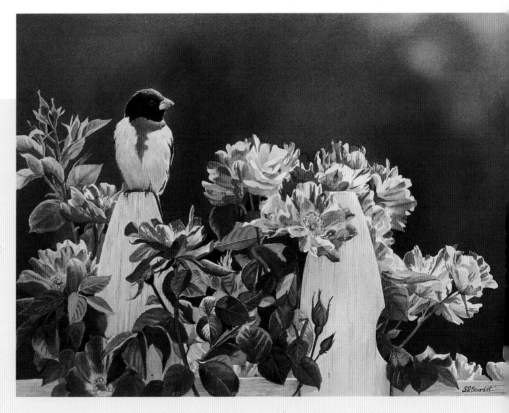

Use a Hair Dryer to Speed Drying
For smooth wet-into-wet washes free of watermarks, it helps immensely to dry the wash with a hair dryer. Hold the nozzle 10 to 12 inches (25cm to 30cm) from the surface (not so close that it pushes the paint around on the paper). Move the dryer back and forth so the whole wash area dries evenly.

A Light Wet-Into-Wet Wash

Often a softly blended, not-too-dark wash is the perfect foil for a detailed foreground subject such as flowers. Use thin color for a very light wash, a little thicker color for medium values. As you flow color onto the wet paper, consider the light direction and also which areas of your foreground composition need the most contrast. For the most attractive soft edges, let the colors blend on the paper. You can suggest some foliage shapes; they'll "stay put" best if the paper isn't too wet when you paint them in.

<div style="border:1px solid">

MATERIAL

Watercolors
HOLBEIN: Hooker's Green • Magenta • Payne's Gray • Permanent Violet

Paper
300-lb. (640gsm) cold-pressed, one-quarter sheet or a scrap

Brushes
1-inch (25mm) or 1½-inch (38mm) wash brush • No. 6 round

Other Materials
Old bath towel • Hair dryer

</div>

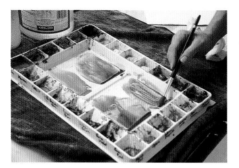

1 MIX YOUR COLORS
Mix puddles of the four colors on your palette. The consistency should be thinner than what you would mix for a dark wash—about the consistency of skim milk.

2 WET THE PAPER
Lay the paper on an old towel and wet it with clean water and a wash brush.

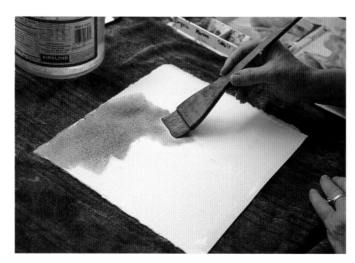

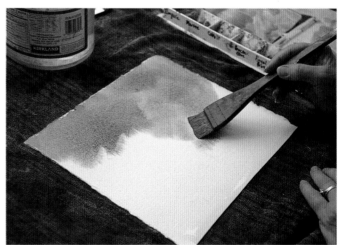

3 LAY IN THE FIRST COLOR
Blot the brush, then pick up some Payne's Gray. Using large, flat strokes, quickly brush this into an upper corner of the paper, then pull the color down into the center. Notice that this thin gray is much lighter when applied to the paper than the thicker gray used in Step 3 of the dark wash demonstration on page 38.

4 CHARGE IN ANOTHER COLOR
Paint some of the thinned Hooker's Green, a transparent green, onto the wet paper, letting it flow right into the gray, that is, "charging" the gray with green. (Hooker's Green, being a transparent green, is more suited for a light wash than the opaque green used in the dark wash demonstration on page 38.)

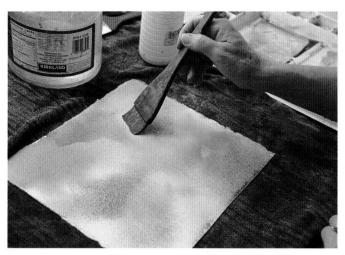

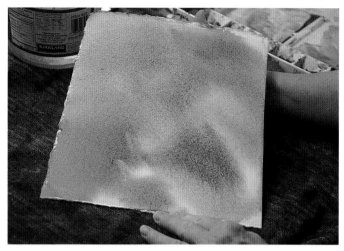

5 ADD MORE COLORS
While the light wash is still wet, paint in some Permanent Violet and some Magenta.

6 BLEND THE COLORS, THEN DRY
Tilt the paper back and forth to blend the colors a little. Dry with a hair dryer.

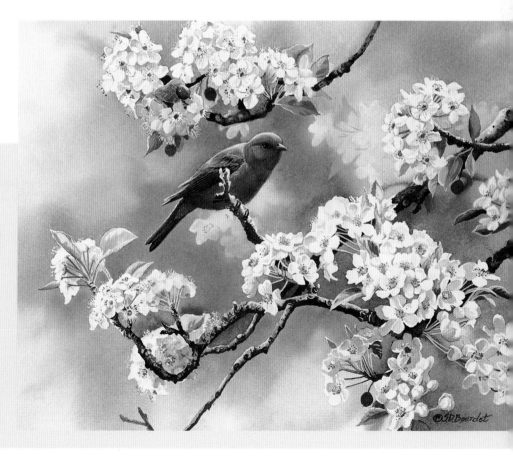

A Light Background Done Wet-Into-Wet
Since hard-edged, well-defined shapes appear to be in front of soft-edged, less-defined shapes, a soft-edged background adds depth and perspective. This light background was painted with a diluted mixture of Payne's Gray and Shadow Green.

SUMMER VISITOR
Scarlet Tanager
Watercolor on 300-lb. (640gsm) Arches
 cold-pressed paper
13" x 16½" (33cm x 42cm)
Collection of Dr. Robert Libman

Problems and Solutions for Wet-Into-Wet Washes

PROBLEM
"Balloons" at the Paper Edge
Balloons are unsightly marks caused when water runs back into the wash from the paper edge.

SOLUTION
To avoid balloons, dry excess water underneath and around the edges of your paper after wetting, or work on a towel.

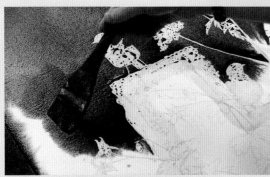

PROBLEM
Streaks
Streaks will result if you don't mix the color thoroughly enough on the palette, or if you put your brush into the pigment well and then directly onto the wet paper.

SOLUTION
Mix your puddles thoroughly, and mix more paint than you think you'll need for a large wash area so you won't run out. If you do run out of a premixed color, mix more on the palette—don't use color straight from the pigment wells.

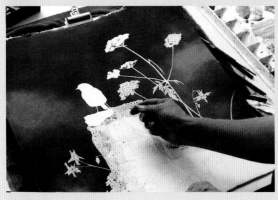

PROBLEM
Lighter-Than-Expected Washes
With the wet-into-wet technique, some colors fade more than others in the drying process. Dark colors usually fade more than you might expect. A wash of Payne's Gray and Compose Green, for example, looks very dark when wet (top), but looks lighter once it has dried (bottom).

SOLUTION
Make your puddles darker than you think they need to be to account for fading. It's a good idea to test a mixture on a scrap piece of paper before beginning a painting.

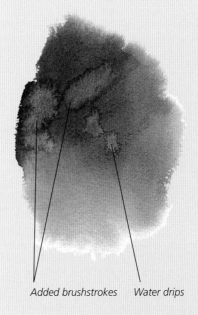

Added brushstrokes Water drips

PROBLEM
"Balloons" in the Middle of a Wash
When a wash has lost its wet shine but is still damp, it's vulnerable. Water brushed or dripped on at this stage will ruin the wash.

SOLUTION
You must work quickly to cover a large background before the shine goes away. If most of the wash has lost its shine before you're happy with it, stop working and dry it until it's bone dry (not even cool to the touch). Then wet it evenly with a spray bottle that emits a gentle spray. You can then gently brush in more color. Don't attempt to add more water with a brush, or some underlying color will be lifted.

Avoid drips by blotting your brush lightly to remove excess water before loading it.

Masking

Often in watercolor painting, you'll want to paint a soft-focus wet-into-wet background, yet you'll also want to paint detailed, well-defined foreground objects. To accomplish this, plan the foreground elements and save them by means of masking before you paint the background.

1 DRAW THE COMPOSITION

Draw your subject on the watercolor paper with as little erasing as possible. (Erasing raises the paper fibers, creating an area that will absorb more pigment when a wash is applied over it. The result is a dark spot in the wash.)

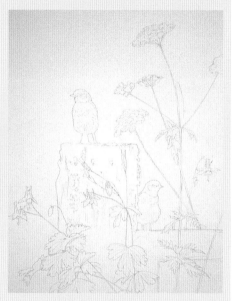

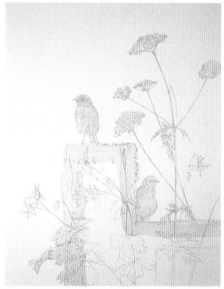

2 APPLY MASKING FLUID

Use a synthetic round brush to paint masking fluid evenly (without streaks or bubbles) and fairly thick on foreground areas you want to save. A no. 2 round is a good size for stems and tight spots; a no. 4 round works well for larger areas. Make sure there are no gaps or bubbles in your application. Let dry completely.

Tips for Working With Masking Fluid

- Make sure your product is reasonably fresh. Old masking fluid will have lost its sharp ammonia smell and can be hard to remove.
- Always stir the mask before using. Don't shake; shaking causes foaming. Use the stir stick or an old brush handle to fish out any globs or curdles before starting.
- Masking fluid will ruin a good brush, so use a synthetic bristle brush. A little bar soap worked into the bristles will help the mask come off the bristles more easily.
- Pause often to rinse any build-up of mask from the brush.
- Be sure the mask is completely dry before you paint the background. As it dries, it will turn from creamy opaque to clear yellow.
- Make sure the painted background is bone dry before you peel off the mask. Keep your hair dryer at least 8 inches (20cm) away from the paper so that the heat doesn't "cook" the mask on and make it difficult to remove.
- To remove mask, try peeling it off with your fingers. If it refuses to peel off easily, use a masking fluid pickup or a little wad of the rubbery used mask to gently rub it off.

3 PAINT THE BACKGROUND, THEN DRY

Mix colors for your background wash. Wet the paper with clean water, extending over the edges of the mask but avoiding any unmasked parts such as the fence post in this example.

Paint your wet-into-wet background. Before it dries, use a damp brush to pick up any puddles that have collected in the spaces between the masked areas. Blot the brush, then pick up the wet paint that has beaded up on the masked areas. For large areas, you can use a scrap of paper towel. This will prevent drips from spoiling your wash.

Dry the wash with a hair dryer, holding the dryer at least 8 inches (20cm) away from the paper.

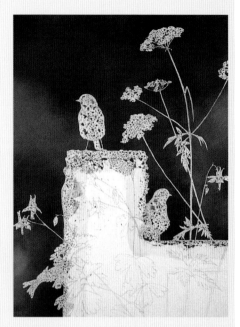

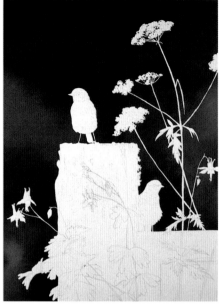

4 REMOVE THE MASK
Peel off the mask. The foreground areas you saved are ready to be painted.

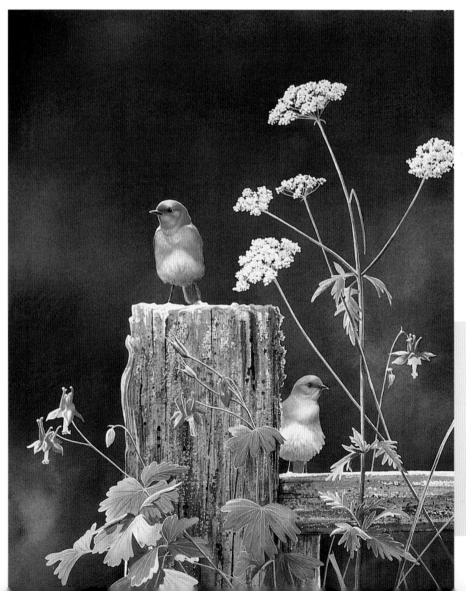

BLUEBIRDS AND QUEEN ANNE'S LACE
Western Bluebirds
Watercolor on 300-lb. (640gsm) Arches cold-pressed paper
20" x 14½" (51cm x 37cm)

Wet-on-Dry

Painting wet-on-dry means applying thinned colors to dry paper. With this technique, the paint stroke stays just where you apply it unless you add more liquid. This method offers more control but lacks the spontaneous blending of wet-into-wet. Wet-on-dry is good for painting smaller areas.

For a crisp edge between two adjacent colors, the first color must be bone dry—not even slightly cool when you touch it with the backs of your fingers—before you apply the second color. Even if the first color is barely damp when you paint on the second color, they will still blend a little at the juncture.

Drybrushing

Drybrushing means picking up color on a damp brush and pulling lightly across dry paper so the pigment is deposited in irregular streaks. The result depends on how much pigment or water you use, as well as the size, shape and stiffness of the brush and whether you drag it or scrub it. Drybrushing is well suited for simulating textures such as rocks, tree bark, wood grain and even fur—situations in which trying to paint the texture on with a detail brush would drive you nuts. Andrew Wyeth was a master at drybrushing and created most of his amazing textures this way.

Wet-on-Dry: Green Painted Before Yellow Was Dry
These colors were applied to dry paper, but the green was painted before the yellow was dry, causing the color to bleed—a minor disaster if you're trying to paint two adjacent shapes that both need crisp edges!

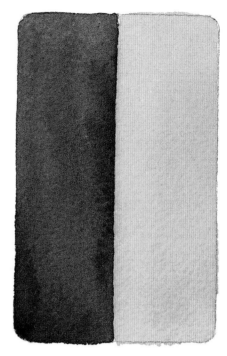

Wet-on-Dry: Yellow Dried Before Addition of Green
These colors were applied to dry paper. Here the first color was dried before the second was painted, resulting in a crisp edge.

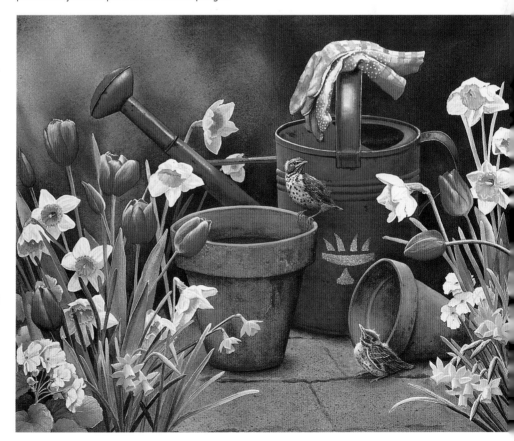

The Versatility of Wet-on-Dry
With the exception of the wet-into-wet background, all of the areas of this painting were done wet-on-dry. The basic concept of thinned pigment applied to dry paper is a simple one, but it is the basis for all kinds of foreground techniques, from simply coloring in an area to painting complicated curved or textured surfaces.

SPRING GARDEN
Baby Robins
Watercolor on 300-lb. (640gsm) Arches
 cold-pressed paper
19" x 29" (48cm x 74cm)

Flat Wash

Flat wash is a method of laying in color over a dry surface, just like painting a wall.

As with the wet-into-wet wash, start by mixing puddles on the palette, suitable for the size of the area you wish to paint. Begin at the top of the wash area, using the largest brush you can. Apply the stroke of color across the area, tilting the paper slightly to make a "drip line" or wet edge at the bottom. Follow with another stroke that overlaps the drip line just a little. Be sure you're picking up color from your puddle and not adding extra water. This will insure that a consistent amount of water is used over the whole area, giving a smoother result.

Like a wet-into-wet wash, a flat wash can be "charged" with another color. The principle here is to work along the wettest edge of the wash, tilting the paper just a little and adding more pigment along the drip line. This is very tricky for large areas, where it is usually more successful to use the wet-into-wet method. But charged washes work well for smaller areas.

Flat Wash
This is a flat wash using Marine Blue.

Charged Flat Wash
Here, a flat wash of Marine Blue is charged with Permanent Violet.

Pulling Out and Building Up

Pulling out is a way to soften and lighten an edge. To practice this technique, apply a patch of color to dry paper. Rinse and blot the brush, then apply the damp brush to one edge of the color patch. Pull the brush away from the color patch, thinning the paint gradually to a lighter value. Rinse, blot and repeat as needed.

Building up means layering washes one over another. Each wash must be dry before the next one is added.

These techniques are used together to create shadow and contour. In this egg study, layers of color are built up to create shadows, with each layer being pulled out toward the highlight area.

MATERIALS

Watercolor
HOLBEIN: Burnt Sienna • Raw Umber

Paper
300-lb. (640gsm) cold-pressed, one-eighth sheet or a scrap

Brushes
No. 4 round

Other Materials
No. 2 pencil

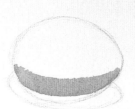

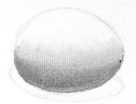

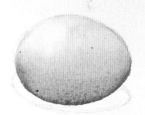

1 SKETCH AND PAINT THE FIRST STROKE

Lightly draw the outline of the egg and its shadow. Make a medium-value mixture of Burnt Sienna and Raw Umber on your palette. Use a no. 4 round to paint a stroke of this across the lower quarter of the egg, leaving a little edge of white at the bottom.

2 PULL OUT COLOR TO BLEND

Rinse and lightly blot the brush. While the first stroke is still wet, apply the damp brush across its top edge so that it bleeds upward into the middle of the egg. Repeat for the bottom edge to bring color down to the pencil line. Rinse and lightly blot the brush again. Before the color dries, blend the upper edge again so that the color fades to white. Dry. Save the color on your palette.

3 START BUILDING UP

Add a little water to your mixture. Paint this new, lighter value around the perimeter of the egg shape, omitting the top left where the highlight will be. Again rinse and lightly blot the brush, then blend this color in toward the center of the shape. Dry.

4 CONTINUE BUILDING UP

Mix a darker value of Burnt Sienna and Raw Umber. Paint another stroke across the lower quarter of the egg, over the previous washes. While the stroke is wet, pull upward to blend softly into the previous washes, but don't cover the lightest values. Rinse and blot the brush, then pull up again until you have an even blend with no hard edges. Dry and save your colors.

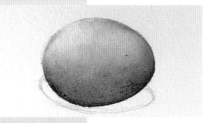

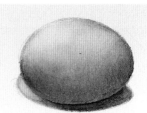

5 PAINT THE SHADOW

Paint the shadow, starting with a dark value at the tapered end of the egg. Rinse and blot the brush, then pull out to a light value at the other end.

MINI-DEMONSTRATION

Glazing

If you thoroughly dry watercolors between coats, you can build up colors and change their hue or value by adding additional layers of color. The process is called glazing.

Glazing works best with very transparent, staining colors because those colors won't "lift" when glazed. Opaque or sedimentary colors are likely to be lifted a bit in the glazing process, making a glazed layer look less transparent.

For a clean, transparent look, apply the darker color over the lighter color. Sometimes, though, you may want to apply a lighter glaze over a darker color to cool or warm it.

Glazing is used most often for creating a three-dimensional look and for painting shadows and reflected light. With glazing, you can mold the form of an object using a range of values.

MATERIAL

Watercolors
WINSOR & NEWTON: Burnt Sienna • Hansa Yellow Light • Payne's Gray • Yellow Ochre

Paper
300-lb. (640gsm) cold-pressed, one-quarter sheet or a scrap

Brushes
No. 8 round

Other Materials
No. 2 pencil

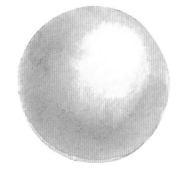

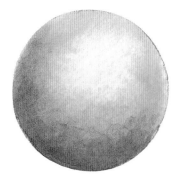

1 SKETCH AND PAINT THE FIRST LAYER

Sketch a circle. Mix a small puddle of light-value Hansa Yellow Light on your palette and apply this to the circle with a no. 8 round. Pull out to create a lighter area and a highlight at the upper right. Dry.

2 START MODELING FORM WITH A SECOND LAYER

Mix a small puddle of Yellow Ochre on your palette. Repeat the process of applying a wash and pulling out toward the highlight, except this time cover a smaller area than in Step 1. Dry again.

3 ADD SHADOWS WITH A THIRD LAYER

Mix a small puddle of Burnt Sienna on your palette and apply this color to the shadow side on the left and to the underside of the ball, again pulling out to the light areas. Be sure to cover less area than in Step 2. Dry.

4 CREATE A SHADOW

Draw a second circle overlapping the first. Mix a small puddle of light Payne's Gray, a cool transparent, on your palette and paint this evenly, wet on dry, over the new circle. Dry quickly. We'll use this glazing technique in nearly every painting to create believable shadows.

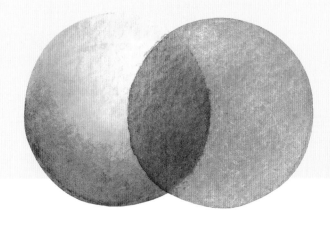

Pulling Out and Glazing to Build Form

As your subjects become more complicated, you will use the same basic techniques as you did for the egg demonstration on page 47, but you'll be painting a variety of shapes with light and shadow playing over each shape in a slightly different way. Color adds another level of complexity to the challenge, as you'll see in this little study.

MATERIALS

Watercolors
HOLBEIN: Burnt Sienna • Compose Green #3 • Greenish Yellow • Hooker's Green • Marine Blue • Permanent Red • Permanent Violet • Permanent Yellow Light • Scarlet Lake

Paper
300-lb. (640gsm) cold-pressed, one-quarter sheet

Brushes
Nos. 2 and 4 round • No. 2 synthetic round for masking

Other Materials
Masking fluid

1 SKETCH

Draw the apples and leaves on the watercolor paper. Use a no. 2 synthetic round to mask a few of the leaf veins.

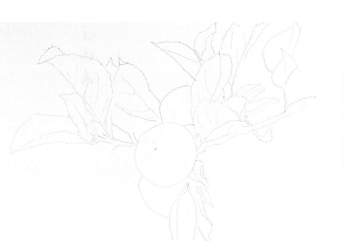

2 BEGIN WITH LIGHT VALUES

Using a no. 4 round and diluted Marine Blue, paint the parts of the leaves that reflect the light. To create the curvature of each leaf, apply the stroke of color to the shadow areas and folds of the leaf and pull out to the white highlights. Dry. Repeat this technique for the backlit parts of the leaves and for the apples, this time using Permanent Yellow Light. Dry again.

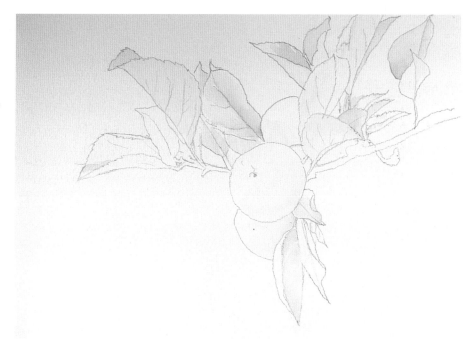

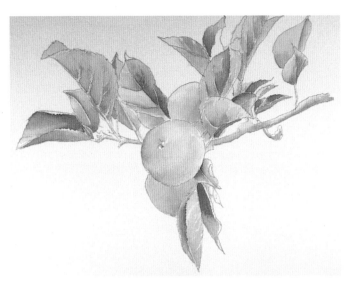

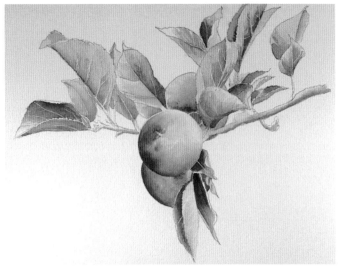

3 BUILD UP WITH A GLAZE OF MEDIUM VALUES

Mix medium values of Hooker's Green, Compose Green #3 and Greenish Yellow on your palette. With the no. 4 round, build up the greens, painting the same areas on the leaves as in Step 2 but not quite covering the first coats. Pull out to the highlights.

Mix medium values of Permanent Red and Scarlet Lake on the palette. Paint the apples, pulling out to blend into the yellow and conserve the highlights.

For the branch, mix Burnt Sienna and Permanent Violet to a medium value. Apply a line of this to the bottom of the branch, pulling out to make the top edge light.

4 BUILD UP FURTHER WITH DARK VALUES

Mix dark values of all the greens and reds in the Materials List. Also mix Burnt Sienna and Permanent Violet to a dark value for the branches. Build up again, placing the darkest values in the shadow areas and folds, and pulling out to conserve the highlights and build up the curved shapes. Dry, then unmask the veins. Save the colors on your palette.

5 ADD FINAL DETAILS

Using a no. 2 round, add a few final dark values from your palette to the leaves and branch. Also enhance the detail of some of the veins with fine lines added just under the masked lines. Add a few touches of Burnt Sienna to the leaves here and there for insect holes. Dry.

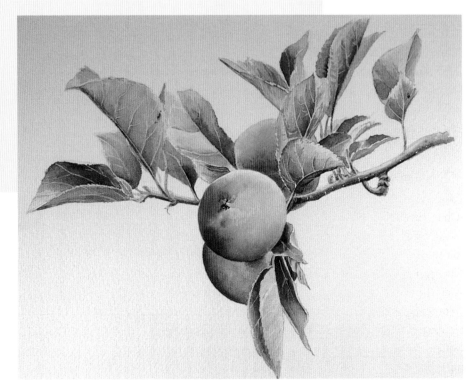

DEMONSTRATION
Young Cottontail

This small study will use all of the techniques you've learned so far. As you work your way through it, you'll discover just how important those simple methods are for creating a rich background and a detailed foreground and in building forms and textures. I encountered this little cottontail rabbit at a cabin in Montana. As he nibbled his way through the owner's garden, I was able to hide behind a gatepost and get some great photos. The soft, dappled light added a gentle warmth to the scene, which I tried to convey by glazing and building up the warm washes that shine through the fur.

MATERIALS

Watercolors
HOLBEIN: Burnt Sienna • Cobalt Blue • Compose Green #3 • Greenish Yellow • Hooker's Green • Naples Yellow • Payne's Gray • Permanent Rose • Permanent Yellow Light • Raw Umber

Gouache
White Designer's Gouache or bleedproof white

Paper
300-lb. (640gsm) cold-pressed, 11" x 14" (28cm x 36cm) • Tracing paper

Brushes
Nos. 2, 4, 6 and 8 round • 1-inch (25mm) flat • Synthetic rounds for masking

Other Materials
No. 2 pencil • Masking fluid • Spray bottle of water • Workable fixative

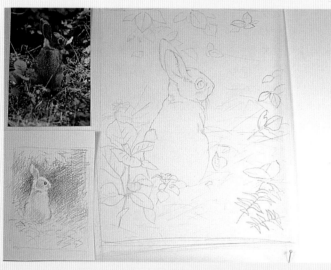

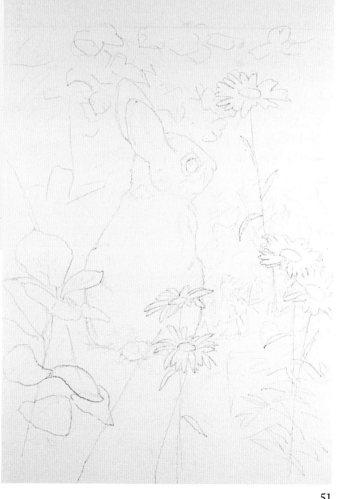

1 PLAN THE DESIGN, THEN SKETCH ON TRACING PAPER

First draw a thumbnail sketch, editing out material in the reference photo that is unnecessary for a painting. (I also added material from other references to strengthen the design.) Then draw the composition at its final size on tracing paper.

2 TRANSFER THE SKETCH TO WATERCOLOR PAPER

On the reverse side of the tracing paper sketch, redraw the lines heavily with a no. 2 pencil. Place the tracing paper right side up on the watercolor paper, tape it in place, and either draw over all the lines again with a pencil or rub the lines with your thumbnail. The graphite on the underside of the tracing paper will be transferred to your watercolor paper.

Erase any unwanted marks and spray the whole surface lightly with workable fixative so the masking fluid in later steps won't pull up the lines.

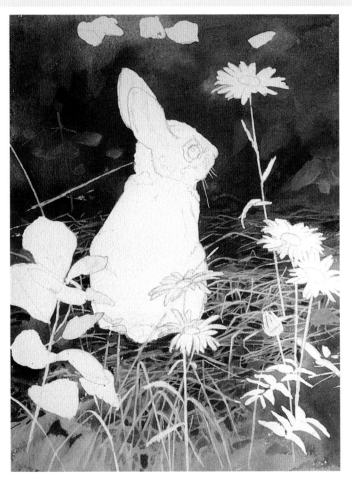

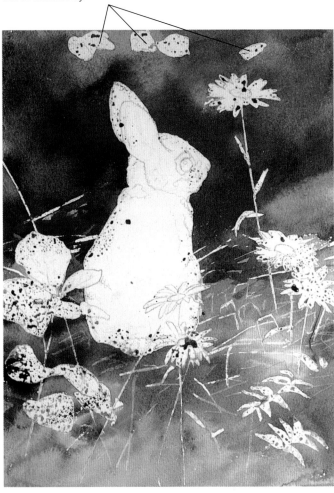

3 APPLY MASKING FLUID AND PAINT THE BACKGROUND WASH

Apply masking fluid to the foreground areas as shown with synthetic rounds. Let the mask dry thoroughly.

Mix large, dark puddles of Payne's Gray and Hooker's Green, and medium-value puddles of Raw Umber and Burnt Sienna. Apply water evenly to the background. While the paper is still shiny, paint the upper background with Payne's Gray and Hooker's Green, using the green to suggest foliage. While this is still wet, paint the lower half using Raw Umber, Burnt Sienna and Payne's Gray. Work the browns up to the greens for a soft edge.

Dry everything thoroughly. Save some of the dark background mixtures for Step 4.

4 RE-MASK THE FLOWER AREAS, THEN PAINT THE GRASSES

Make sure the painting is bone dry, then spray the background area lightly with water. Use a no. 6 round to paint in a few leaf shapes with Compose Green #3.

Remove the mask. Re-apply masking fluid to the flowers and stems only where they overlap the rabbit. Dry. Then, working wet-on-dry, glaze lightly over the middle ground with a light value of Raw Umber to tint the unmasked grasses, leaving a few blades in the extreme foreground unpainted.

Dry the painting again, then use a mixture of Payne's Gray and Burnt Sienna to darken some of the spaces between and under the grasses to give them a sense of depth. Add a little white Designer's Gouache or bleedproof white to some Naples Yellow, then use a no. 2 round to paint in some lighter grasses here and there in the foreground.

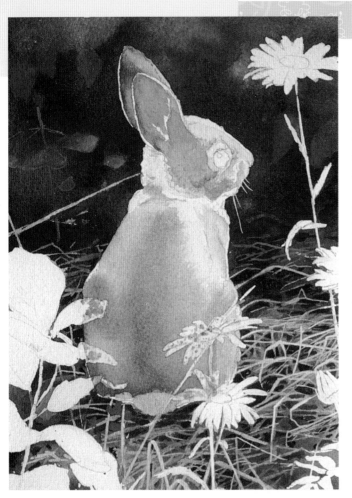

5 PAINT THE UNDERWASHES ON THE RABBIT

For the inside of the ear, mix small medium-light puddles of Burnt Sienna and Permanent Rose. Using a no. 4 round, apply Permanent Rose to the lower inside of the ear and pull up to the upper rim, leaving a fine white edge. Dry.

Again using a no. 4 round, apply Burnt Sienna to the ear's left rim, leaving a white edge and a few unpainted marks to suggest hairs. Pull out toward the left, stopping at the fold. Mix a little Payne's Gray into the Burnt Sienna to make a dark brown. While the ear is still damp, apply this color to the lower inside and the rim of the ear, avoiding the white edge. Dry. Mix a little water with some white Designer's Gouache or bleedproof white and use a no. 2 round to suggest fine hairs inside the ear and around the edges.

For the inside of the ear, mix a light wash of Burnt Sienna and Permanent Rose. Paint this mixture in the inside of the ear, pulling up to a lighter value toward the tip.

Paint the initial washes for the rabbit's body according to the instructions in the Detail Demonstration below.

DETAIL DEMONSTRATION: Underwashes for the Rabbit

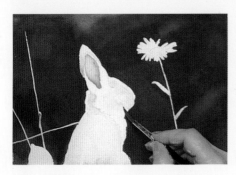 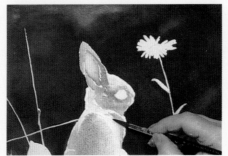 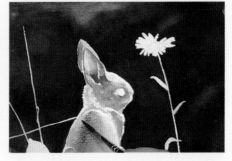

1 PAINT A LIGHT WASH OF NAPLES YELLOW

Using a no. 8 round, apply a light coat of clean water to the rabbit only. Don't use too much water; the paper should be just barely shiny. You want more control than you would for a large background. With the same brush, paint a light wash of Naples Yellow on the sunlit areas, conserving the white highlights. Be sure to control the amount of water; the color should bleed slightly but not run.

2 ADD A PALE BROWN MIXTURE

Rinse and blot the brush, then pull out color so the inside edges of the wash area are soft. Mix a light-value puddle of Burnt Sienna with a little Payne's Gray. While the yellow wash is still wet, use this mix and a no. 6 round to paint the rabbit's back, flanks, shoulder and cheek, pulling the brown out to create soft blends. Dry.

3 BUILD UP WITH A DARKER BURNT SIENNA—PAYNE'S GRAY MIXTURE

Make a medium-value mixture of Burnt Sienna and Payne's Gray. Using a no. 6 round, build up the same brown wash areas as in the previous step, not quite covering the soft edges of the lighter brown underwash. Dry.

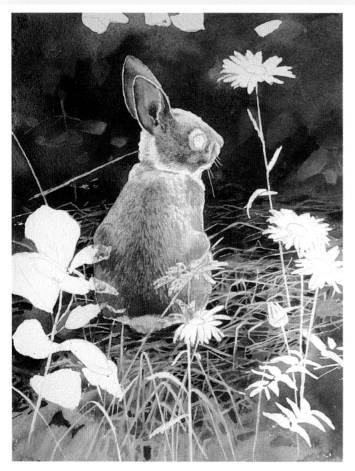

6 BUILD UP COLOR ON THE RABBIT

Wet the rabbit lightly with clear water a second time, then paint another wash over the first, laying in some darker color and blending with the wet brush. Don't entirely cover the previous wash, but build up the darker areas of the coat and the shadows.

While the rabbit's coat is still damp, but not shiny, use a no. 2 round to suggest some fur by painting fine strokes of a darker-value mix of Burnt Sienna and Payne's Gray. The paper should be damp enough that you can pull the fine strokes evenly, but not so damp that the strokes bleed into the wash. Test the mixture on a small area to make sure the dryness is right.

7 FINISH THE FUR, EYE AND EARS

Once the undercoat washes are dry, it's time to start adding fur detail. Instead of trying to paint the hairs, you'll paint the spaces between them, letting the lighter-colored underwash show through to indicate fur texture.

Mix a dark brown using Payne's Gray and Burnt Sienna. Pull aside a small portion of that mixture and add a touch of Cobalt Blue for the cooler shadowed area near the rabbit's tail. Mix a little water and some Naples Yellow into some white Designer's Gouache or bleedproof white. Using a no. 2 round, add some fine light hairs over the top of the fur texture to suggest fluffiness.

Paint the eye and finish the ears according to the instructions in the Detail Demonstrations on the next page.

DETAIL DEMONSTRATION: Eye

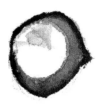

1 PAINT THE IRIS, EYELID AND BLUE REFLECTION

Use a no. 2 round to paint the iris with a light mix of Burnt Sienna, avoiding the highlight. While the iris is damp, paint the dark line of the inner eyelid with a mix of Burnt Sienna and Payne's Gray, blending a little to soften. Dry.

Paint the blue reflection with light Cobalt Blue, being sure to preserve the highlight. Dry again.

2 PAINT THE PUPIL AND THE EYELID'S OUTER EDGE

Paint the pupil with dark Payne's Gray, conserving the blue reflection and the highlight. While the pupil is still damp, blend it just slightly into the iris with a damp brush.

Use a diluted mix of Payne's Gray and Burnt Sienna to paint a fine line around the outer eyelid, leaving a thin edge of white on the left side of the lower lid.

3 ADD FUR DETAILS AROUND THE EYE

Again with a no. 2 round, use pale mixtures of Payne's Gray and Burnt Sienna (some a little more Sienna, some a little more gray) to paint fine hairs around the eye area. Leave a patch of white above the eye for the brown and another under the lower eyelid line.

DETAIL DEMONSTRATION: Finishing the Ear

1 CREATE FUR TEXTURE

Mix a little Naples Yellow with white Designer's Gouache or bleedproof white and use a no. 2 round to paint fine light hairs on the right and left sides of the ear, omitting the pink area. Also paint some light hairs starting at the lower right edge, pulling them into the dark part of the inner ear and the pink area.

2 ADD COLOR AND DETAIL

Build up the pink area with a Burnt Sienna–Permanent Rose mix. While it is still damp, add veins with a darker mix of the same colors. Paint the dark patch inside the ear with a browner mix of the same colors, avoiding the white hairs. Use a little Burnt Sienna mixed with Payne's Gray to paint the dark rim and to add some fine hairs. Soften the rim slightly with a damp brush.

DETAIL DEMONSTRATION: Leaves

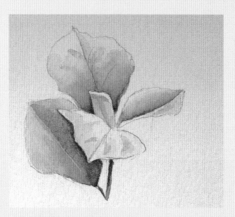

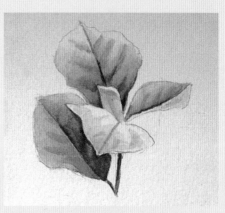

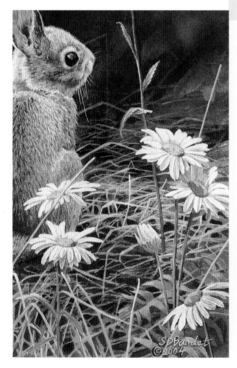

8 **ADD LEAVES**
Paint leaves according to the instructions in the Detail Demonstration at right.

1 **APPLY THE INITIAL GREENS**
Make a dark-value mix of Compose Green #3 and Hooker's Green. On the lightest leaf areas, use a no. 2 round to merely suggest a few veins. Elsewhere, paint the shadow part of the leaf, then pull up to the highlights. Dry. Save your colors.

Paint light Greenish Yellow on areas where you want to suggest translucence. Dry for a moment, then soften the veins with a damp brush.

2 **BUILD UP THE VALUES**
Returning to the dark green mix from Step 1, build up the values on the leaves and veins, blending with a damp brush. Dry. Mix a medium value of Burnt Sienna and use this to paint the stems and center veins.

DETAIL DEMONSTRATION: Flowers

9 **ADD FLOWERS**
Paint flowers according to the instructions in the Detail Demonstration at right.

1 **PAINT THE SHADOW AREAS**
Using a no. 2 round, paint the shadow areas on the daisy petals with a light mix of Payne's Gray and Cobalt Blue. Dry.

2 **PAINT THE FLOWER CENTERS**
Paint the flower centers with a medium value of Permanent Yellow Light. Dry. Paint the shadow side of each flower center with a medium-light value of Raw Umber, pulling out to keep the top light. Dry. Add a dot of Raw Umber in the middle of each flower and a few short strokes here and there.

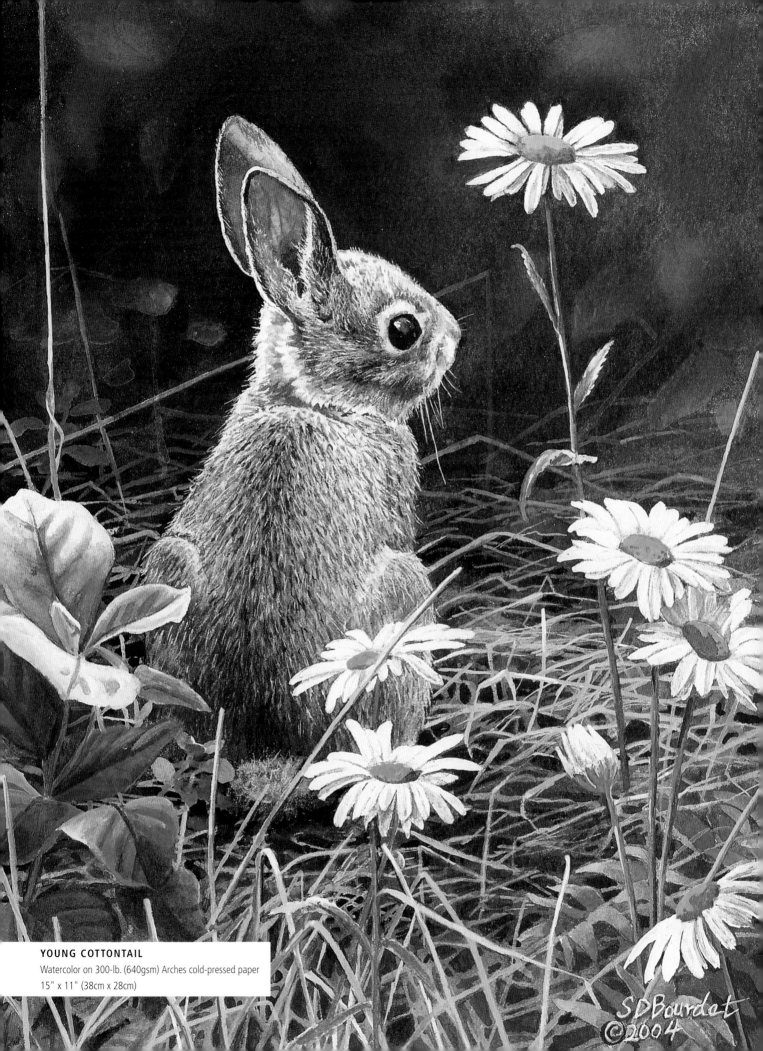

YOUNG COTTONTAIL
Watercolor on 300-lb. (640gsm) Arches cold-pressed paper
15" x 11" (38cm x 28cm)

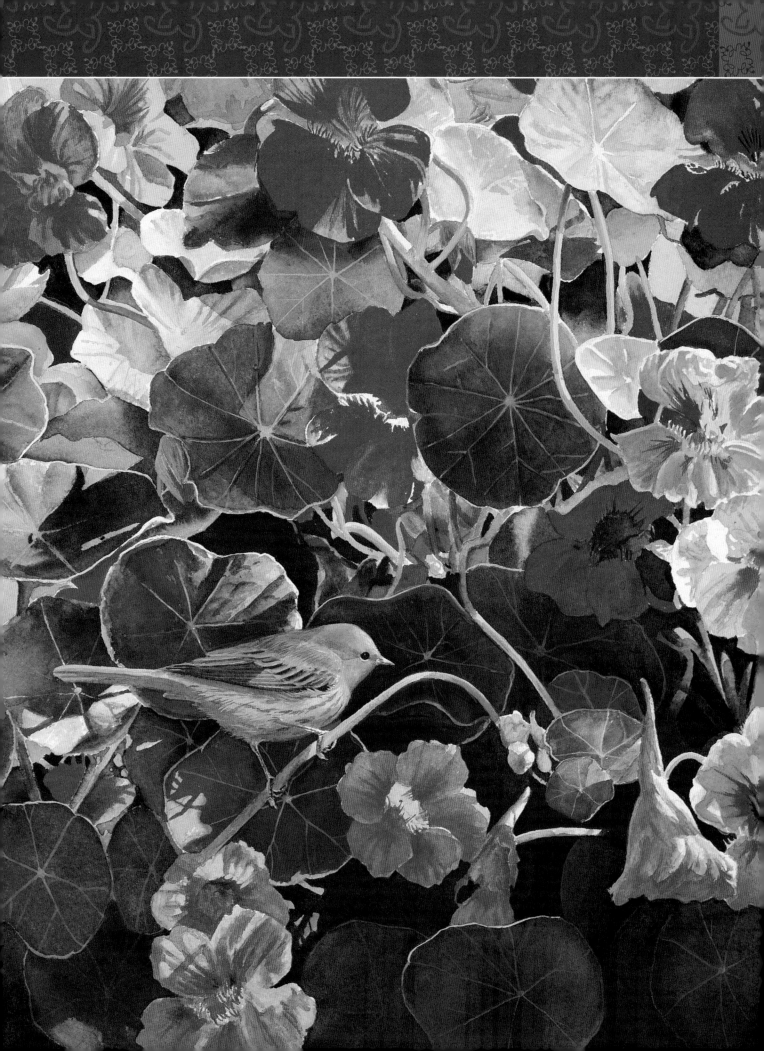

4 PAINTING NATURE'S LIGHT

Recently I juried a watercolor show with a nature theme. As I walked into the room and saw the show hanging, I was struck by how some paintings had real impact, even from a distance, while others just didn't speak to me. More often than not, the most exciting paintings were of subjects that were simple and familiar, maybe even commonplace. What set them apart was the artist's use of light. In this chapter, you'll learn light and shadow basics as well as techniques for painting different types of light, so that you, too, can make paintings that reach out and draw viewers in.

SUMMER GOLD
Yellow Warbler
Watercolor on 300-lb. (640gsm) Arches cold-pressed paper
16¼" x 13¾" (41cm x 35cm)

Light and Shadow Basics

Shadow Anatomy

To learn how light and shadow work, study the shadow elements, then practice creating them with the examples in this chapter. Mastering light and shadow on basic round shapes will help you because every sunlit object you paint will contain the following shadow elements:

Highlight: Where the light is hitting most directly; bright white.

Shadow Core: The coolest, darkest part of the shadow, opposite the highlight.

Turning Point: Where the shadow fades, its color temperature turning from cool on the shadow side to warm on the lit side.

Reflected Light: Light bounced back onto the object from the surface it rests on.

Ambient Shadow: A shadow that gives contour to a shape even in very low light. An ambient shadow has no distinct edges.

Cast Shadow: A well-defined shadow created when there is a bright light source. Length, sharpness, color and shape vary with the time of day and the quality of the light. A cast shadow is roughly 40 percent darker than the surface's basic hue.

Using the Basic Techniques to Paint Light

To paint light with watercolor, you must constantly change and adjust hue, value and temperature. Do this by using all of the basic watercolor techniques we covered in Chapter Three: washes, masking, pulling out, building up and glazing. Masking can preserve your brightest highlights, or you can lift out highlights. Pull out and build up color to establish the lightest values and to build form. Charged washes are good for creating soft color transitions. Use glazing to build up color and to further build form.

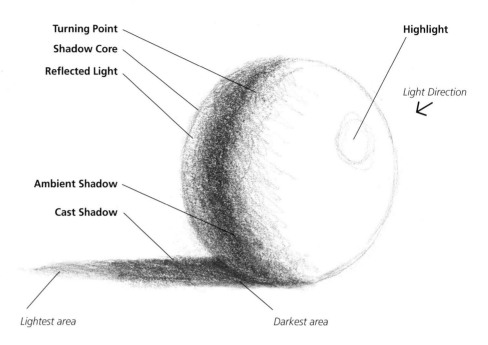

Turning Point
Shadow Core
Reflected Light
Highlight
Light Direction
Ambient Shadow
Cast Shadow
Lightest area
Darkest area

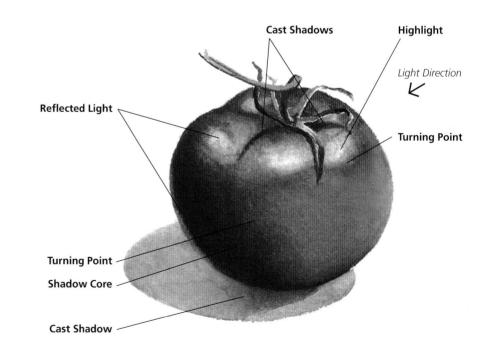

Cast Shadows
Highlight
Light Direction
Reflected Light
Turning Point
Turning Point
Shadow Core
Cast Shadow

Creating Believable Shadows

Light and shadow are inseparable; you can't have one without the other. So to depict light, you must learn to paint realistic shadows.

Shadow Angle

In order for a made-up scene to look believable, light must come from the same direction throughout—meaning shadow angles must be consistent.

Value

In general, the brighter the sunlight, the darker the shadows. Don't be afraid to paint dark shadows when they're needed; a painting without enough value contrast looks flat. A shadow needs to be at least 40 percent darker than the base color of the object in order to look realistic. Squinting at your reference will help you see this contrast.

Moreover, shadow values in a painting need to be consistent. The shadows of two nearby objects should be equally dark, and their highlights should be equally bright.

Color Variation

Shadows aren't uniform in color. The colors of nearby objects and surfaces affect shadow color. Also, shadows become lighter and cooler as they get farther from the object casting them.

Color Temperature

Just as the angle of sunlight needs to be consistent in a painting, so does the color temperature. This is one reason why using references from different times of day can be difficult. The color temperature of a shadow depends on the time of day and on the temperature of reflected light from nearby objects. To be safe, plan your shadow colors in advance and compare them for consistent value, color and temperature. I like to think of a shadow as a glaze that falls over an object, causing it to change color and temperature.

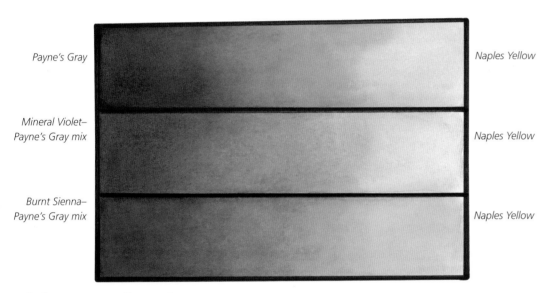

Payne's Gray *Naples Yellow*

Mineral Violet–Payne's Gray mix *Naples Yellow*

Burnt Sienna–Payne's Gray mix *Naples Yellow*

Shadows Are Never All One Color
Part of the secret of painting shadows is to use gradual color gradations. This chart shows gradations from shadow to highlight in three different shadow colors. Here I mixed each shadow color with Naples Yellow, a warm light, to give each example the same temperature.

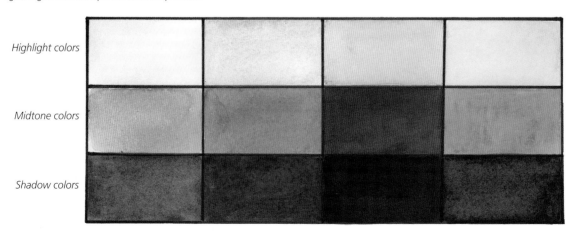

Highlight colors

Midtone colors

Shadow colors

Use Value and Temperature Consistently
Highlight value and temperature need to be applied consistently throughout a painting, regardless of the base colors of the objects. The same is true for shadow value and temperature.

Five Light Effects

In this study are five teacups lit from different directions. Because each cup is white, you can see how the play of light on the surface creates a variety of warm and cool tones and differently placed highlights and shadow patterns.

The highlights will be located where the light is brightest—where it strikes the surface with the most intensity. The values will be increasingly dark as you look away from the highlight, and the deepest, darkest part—the core of the shadow—will be directly opposite the brightest highlight.

The soft-edged shadows on the body of the cup are ambient shadows. The harder-edged cast shadows happen when an object is in front of a bright light source and blocks the light in a pattern corresponding with its shape. Notice how the cast shadows vary in shape with the angle of the light source. In some of the studies, you can also see how the light from the tabletop is reflected back, warming the ambient shadow on the cup.

A. Frontal Light
When the light comes from directly in front of the cup the highlight is right in the middle of the bowl, and the core of the shadow, invisible to us, is in the center of the back side. The cast shadow is behind the cup.

B. Side Light From the Right
When the light comes from a low source to the right of the cup, the highlight is on the right side of the rim and bowl and the shadow core on the opposite side, just out of view.

C. Backlight
With the light directly behind the subject, the core of the shadow is front and center while the highlight is at the center of the opposite side that we don't see. The cup casts its shadow directly in front, with the core of the cast shadow right under the core of the ambient shadow on the bowl. We see some reflected light from the table on the lower bowl of the cup and a little translucence on the back rim where the light shines through.

D. Overhead Light From the Left
Here the light comes from right above the cup, so the highlight is on the rim with the bowl in shadow. The whole cup casts a shadow, and there is a little cast shadow on the bowl from the cup handle.

E. Overhead Light From the Front Right
In this case, the light source is slightly in front of and above the cup so that the rim is highlighted while most of the bowl is in shadow. The cast shadow has a different shape because the light source comes from the opposite side.

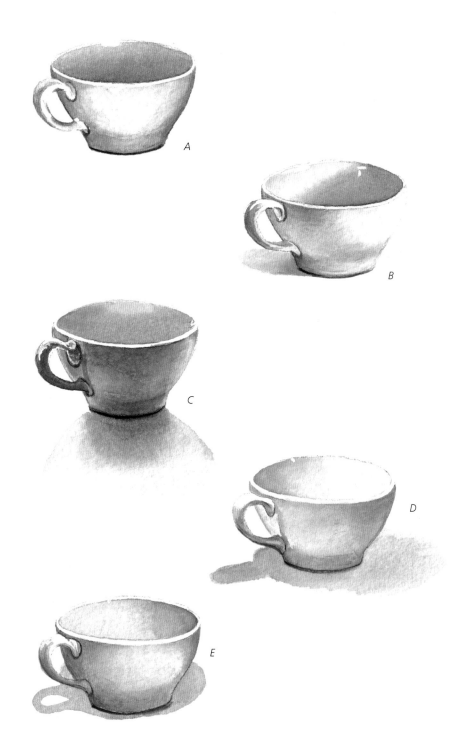

Shadows at Different Times of Day

Let's look at some living subjects to see how time of day dramatically affects the amount of contrast.

Midday light is very strong, creating maximum contrast between sunlit and shadowed areas. Since the light angle is steep, shadows are directly under the subject and are uniformly dark, not fading to soft blues and grays at the edges. The edges of the cast shadows are crisp and defined. Even the turning edge from highlight to shadow on the bird's body is fairly defined. Much detail is either lost in the deep shadows or washed out by strong light.

Late afternoon light is low-angled, so cast shadows lengthen and take on interesting shapes. With less contrast between sunlit and shadowed areas, both brightly lit and shadowy areas are detailed and colorful. The turning edges (from shadows to highlights) on the birds are less defined. The cast shadow becomes lighter and cooler as it gets farther from the subject. There is also some reflected light on the subjects, adding even more interest.

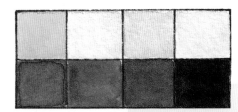

Value Chart: High Noon

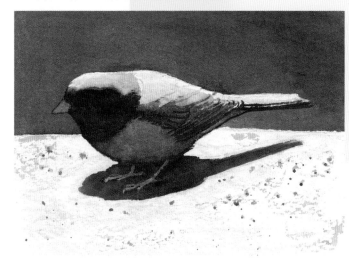

Junco at Noon
Notice that there are fewer colors and that the values are either very dark or very light, with few middle tones. Details are hard to see because of the high contrast.

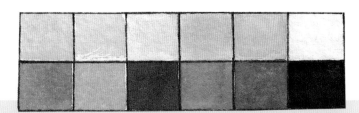

Value Chart: Late Afternoon

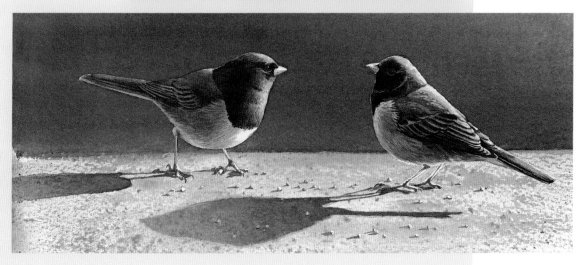

A Junco Pair in Late Afternoon
In low-angled light, there are more middle values and colors in the birds and in the shadows. Because the surface the birds are standing on is warmly lit, you see some warm reflected light. There are more middle tones, and there is less difference between dark and light values.

63

Painting Cast Shadows

As the direction of the light changes, so must the lighting in your compositions. Let's look at a few more examples of strong directional sunlight. In each case, you can see that the angle of the light is revealed by the angle of the cast shadows in the painting. This angle needs to be consistent throughout the composition.

Light From the Upper Right Side
In the case of these barn swallows, the sun is a little lower, making the angle of the shadows less steep than it was in the finch painting.

BARN SWALLOWS AND RAIN BARREL
Watercolor on 300-lb. (640gsm) Arches
 cold-pressed paper
12" x 15" (30cm x 38cm)

Light From the Upper Left
In this painting, the light source is high on the left side of the painting. The steep angle of the light is revealed by the cast shadow under the finch's beak. The same angle needed to be repeated throughout the setting, which resulted in some of the quince leaves being lit from behind.

FINCH AND QUINCE
House Finch
Watercolor on 300-lb. (640gsm) Arches cold-pressed paper
10" x 15" (25cm x 38cm)
Collection of Mr. and Mrs. F. Murphy

Light From the Front

Here the light is softer—the kind of light you might have on a bright overcast day—resulting in a composition without cast shadows. The source is in front of and slightly to the left.

MOUNTAIN BLUES
Mountain Bluebird
Watercolor on 300-lb. (640gsm) Arches
 cold-pressed paper
12" x 15" (30cm x 38cm)

Light from Behind

Here is an example of backlight—when the light comes from behind the subject. Notice that light edges the cardinal, which has very dark values because the light actually shines on the other side of it. The light also outlines the edges of the snow, but it shines through the translucent areas.

DECEMBER DAWN
Northern Cardinal
Watercolor on 300-lb. (640gsm) Arches
 cold-pressed paper
15" x 16" (38cm x 41cm)

Principles for Painting Cast Shadows

- A cast shadow will be darkest right next to or directly under the object that casts it.
- Most of the time, a cast shadow will be warmest right next to the object that casts it, then cooler and lighter as it lengthens.
- The shadow edges will be hardest near the object and softer farther from it.
- Since there is only one sun, shadow angles need to be consistent throughout a painting.
- The value of a cast shadow depends on the brightness of the sunlight. This means that the brightest highlights will correspond to the darkest shadows. The degree of contrast between sunlit and shadowed areas will decrease as the brightness of the light decreases.
- Remember that on an overcast day there may be no cast shadows at all.

Bright Sunlight and Cast Shadows

For any painting in which the sun is the sole light source, the light must come from the same place throughout the painting. If there are cast shadows, study their angles carefully because the shadow angles need to be the same throughout the composition. Find references that are as closely related in light quality as possible, making the light the main criterion in deciding which photos to use.

Adapt the Shadows When Combining References

In my reference photo of the stairs, the light coming through the rail fell in an interesting pattern across the steps. I wanted to add the cat in a spot where the rail shadows would fall on her. Since the light in the rest of the reference was correct, I just approximated the angle and curved the shadow over the form.

SOPHIE'S PLACE
Watercolor on 300-lb. (640gsm) Arches
 cold-pressed paper
29" x 22" (74cm x 56cm)
Collection of Mr. and Mrs. William Turnquist

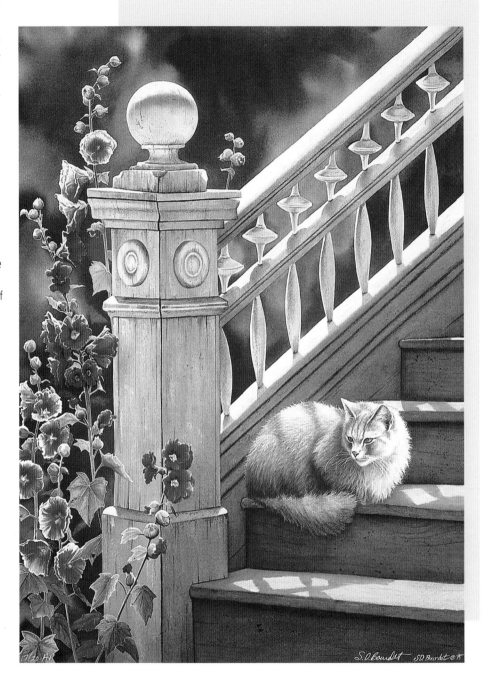

Pitfalls to Avoid When Painting Bright Sunlight

- Make sure the light angles are consistent throughout a sunlit scene, or you will create the appearance of more than one sun.
- The edge of light around a backlit subject should not be uniform in width, but variable, following the subject's contours.
- Evaluate the degree of contrast between highlights and shadows. It should be consistent throughout the painting.
- Don't paint one-color shadows.
- Don't hesitate to go beyond what you see in reference photos. Often the most beautiful effects come from exaggerating reflected light or changing shadow color.

Light as a Design Feature

Shadows are an important element of your design. Looking at them simply as darks and lights, the shadows should make an interesting abstract pattern. This pattern represents the "bone structure" underneath the more obvious subject matter. Before you start your painting, make a value study, considering all dark and light areas but leaving out lines and details. That way you can check the abstract shadow pattern for the accuracy of light angles and for strong design.

Diagonal Shadows Create Drama

This painting is all about the dramatic canyon setting. The shadowy clefts in the rocks make a strong diagonal pattern that emphasizes the verticality of the cliff and moves the viewer's eye around the composition.

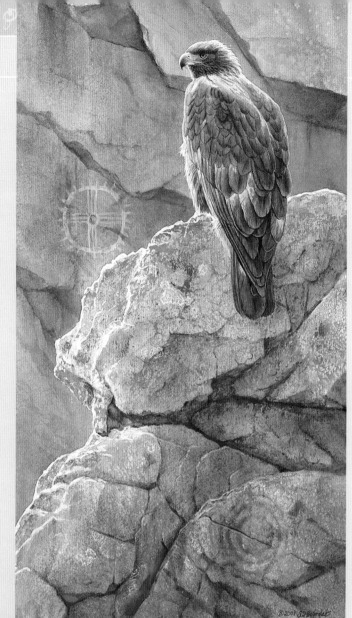

ANCIENT GUARDIAN
Golden Eagle
Watercolor on 300-lb. (640gsm) Arches cold-pressed paper
20" x 28" (51cm x 71cm)

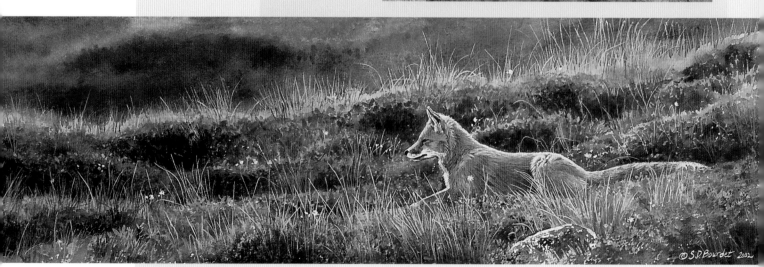

Light Patterns Can Unify a Composition

The backlight gliding over the fox's fluid form is echoed in the way the light plays over the hills and hummocks of the setting, helping to unify the composition.

ON THE SLY
Red Fox
Watercolor on 300-lb. (640gsm) Arches cold-pressed paper
9" x 19" (23cm x 48cm)

DEMONSTRATION
Overhead Light

This sleepy colt in the spring sunshine made me want a nap, too. With the sun high overhead, the angle from sun to subject is steep, making the cast shadows short and dark. I began by establishing the darkest darks with my washes, then blending in the other colors of the coat with a damp brush. Notice that the coat colors and shadows have soft edges, while the cast shadows are hard-edged.

MATERIALS

Watercolors
HOLBEIN: Burnt Sienna • Cobalt Blue • Naples Yellow • Gamboge Nova • Payne's Gray • Sap Green

Gouache
White Designer's Gouache

Paper
300-lb. (640gsm) cold-pressed, 9" x 12" (23cm x 30cm)

Brushes
1-inch (25mm) flat • Nos. 2 and 6 round • No. 4 synthetic round for masking

Other Materials
Masking fluid • Workable fixative

1 DRAW AND MASK, THEN PAINT THE BACKGROUND

Draw the colt on the watercolor paper, then spray with workable fixative. Mask the colt and dry.

Mix two mixes of Naples Yellow, Burnt Sienna and Payne's Gray: one cooler, with more Payne's Gray, and one warmer. Paint the background area behind the colt with the cooler gray mix. While that is still wet, paint the foreground area with the warmer gray, allowing the two colors to blend. Dry.

For the foreground, make a medium-value mix of Payne's Gray and Burnt Sienna. Pick up some of this mix on a damp no. 6 round and brush it lightly over the warm gray so that color is deposited on the bumps of the paper. Use a no. 2 round and mixes of the same two colors to paint a few pebbles and rocks. Paint some grass blades with Sap Green. Dry, then remove the mask.

2 PAINT THE CAST SHADOWS

Make small puddles of dark Payne's Gray and medium-value Cobalt Blue. With a no. 2 round, paint the shadow area by the colt's neck with Payne's Gray. Charge in some Cobalt Blue and pull out so the shadow is darkest right next to the colt and becomes lighter and bluer toward its outer edge. Repeat this process to make shadows behind the foreground rocks.

Mix the Payne's Gray and Cobalt Blue and add some Burnt Sienna to make a very dark gray, almost black. Use this to paint the shadows on the back of the neck, the ears, and under the shoulder and legs. Use a damp brush to blend the inner edges of the shadows on the neck and ears, leaving the mane and ear edges hard except where the darkest part of the neck meets the cast shadow. Add a few rough hairs for the mane with Cobalt Blue. Dry.

Eye and Fur Detail

Use a no. 2 round and a dark Burnt Sienna–Payne's Gray mix to paint the pupil of the eye. Outline the lids, leaving a tiny pale edge to highlight the lower lid and a little edge on the upper lid for lashes. Detail the coat with fine lines of a diluted mix of Naples Yellow and white Designer's Gouache.

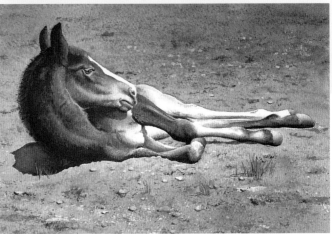

3 PAINT THE HORSE'S COAT

With a no. 6 round, paint a light coat of Naples Yellow on the colt, avoiding the blaze on the nose and the white areas on the legs. Dry. Dampen the head and neck with a wet brush, then paint the rusty areas with Burnt Sienna, blending to soften. Dry. For the darkest areas, apply a mix of Payne's Gray and Burnt Sienna, pulling out into but not covering the Burnt Sienna. Dry. Scrub a little with the same dark mixture to simulate the fuzzy coat. For the chest, forelegs and hip, dampen each area first and apply Burnt Sienna, pulling out to the light areas. Use lighter Burnt Sienna for the hip.

4 ADD DETAILS

Mix small puddles of Payne's Gray and Cobalt Blue on your palette. Use a mix of these two colors and a no. 6 round to paint the cast shadow on the lower foreleg, pulling out to make the inner edge lighter and bluer. Add Burnt Sienna to the Payne's Gray, then paint the areas around the lips, nose, knees and ankles. Use the same mix to paint the area around the eye, pulling out to make highlights on the cheekbone and eyebrow. Leave a rim of yellow just under the eye. Add a touch of Cobalt Blue to the mix, then paint the hooves.

Mix a puddle of Sap Green on your palette. At one edge of the puddle, mix in a little Cobalt Blue; to another edge, mix in a little Gamboge Nova. Paint the grass behind and beside the colt with the blue-green mix. While this is still wet, paint in unblended Sap Green. Switch to the yellow-green mix for the foreground. Dry. Paint a few grass blades with a darker value of Sap Green and a no. 2 round.

Finish as directed in the Eye and Fur Detail above.

SLEEPY COLT
Watercolor on 300-lb. (640gsm) Arches cold-pressed paper
9" x 12" (23cm x 30cm)

DEMONSTRATION
Backlighting

Backlighting, one of the most dramatic effects you can use in a nature painting, works its magic in this little egret study. What I love about backlighting is that it illuminates the edges of the subject and makes fur, feathers and leaves look as translucent as stained glass.

Important to this study is the warm reflected light on the bird's plumage. The shadowy front of the bird is not only blue, as you'd expect, but violet and even gold because of the reflections. Also notice that the beak appears translucent.

MATERIALS

Watercolors
HOLBEIN: Burnt Sienna • Cobalt Blue • Naples Yellow • New Gamboge • Payne's Gray

Paper
300-lb. (640gsm) Arches cold-pressed, 7" x 13" (18cm x 33cm)

Brushes
1-inch (25mm) flat • Nos. 2, 4 and 6 round • No. 2 synthetic round for masking

Other Materials
No. 2 pencil • Masking fluid • Spray bottle of water • Workable fixative

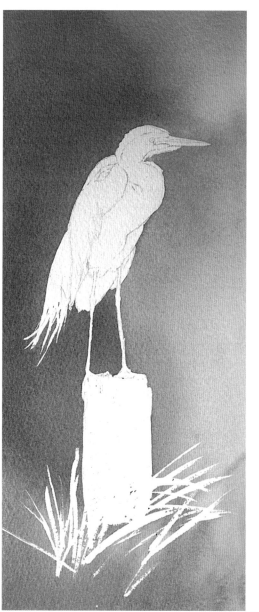

1 DRAW AND MASK, THEN PAINT THE BACKGROUND

Draw the composition on the watercolor paper with a no. 2 pencil, then spray lightly with workable fixative. Use a no. 2 synthetic round to mask the egret, the stump and some grasses. Let the mask dry thoroughly.

Mix a dark puddle of Payne's Gray and a smaller dark puddle of Burnt Sienna. Mix a bit of the Burnt Sienna into the Payne's Gray to make a cool dark gray. Wet the background area with a 1-inch (25mm) flat, then paint the cool gray mix onto the left side of the painting, tilting the paper so the color moves across it. Add a little lighter pure Payne's Gray to the lower right side and tilt the paper again to blend the color. Dry.

Use a spray bottle to lightly wet the lower foreground. Make a light golden mix of Naples Yellow and Burnt Sienna and use a 1-inch (25mm) flat to paint the grass area. Dry. Use the same brush to paint a light wash of Payne's Gray over the lower part of the grass. Dry, then remove the mask.

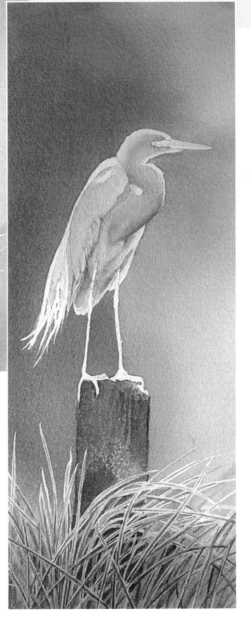

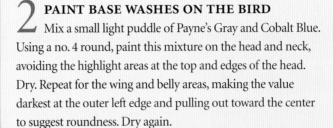

2 PAINT BASE WASHES ON THE BIRD

Mix a small light puddle of Payne's Gray and Cobalt Blue. Using a no. 4 round, paint this mixture on the head and neck, avoiding the highlight areas at the top and edges of the head. Dry. Repeat for the wing and belly areas, making the value darkest at the outer left edge and pulling out toward the center to suggest roundness. Dry again.

Mix Payne's Gray and Burnt Sienna to a medium value and apply a wash of this to the stump, leaving an edge of white at the top. Dry.

3 BUILD UP THE WASHES

Make a small puddle of a medium Payne's Gray–Cobalt Blue mix. Again paint the head and neck, starting with the outer (left) edge. Pull out so that the lighter wash shows at the inner edge and the neck looks rounded. For the wing area, again make the value darkest at the outer edge and pull in toward the center for a feeling of roundness, not covering your lighter wash at the inner edge of the wing. Dry.

Paint the grasses with Naples Yellow, making them lighter at the tips. Dry, then detail the grasses with medium-value mixtures of Payne's Gray and Burnt Sienna, varying the color to make some of the grasses browner and others grayer. Dry. Add some gray-blue around the tip and edge of the tail, at the front of the neck and in the "nooks and crannies," leaving the outside edge white. Drybrush the stump with a mix of Payne's Gray and Burnt Sienna.

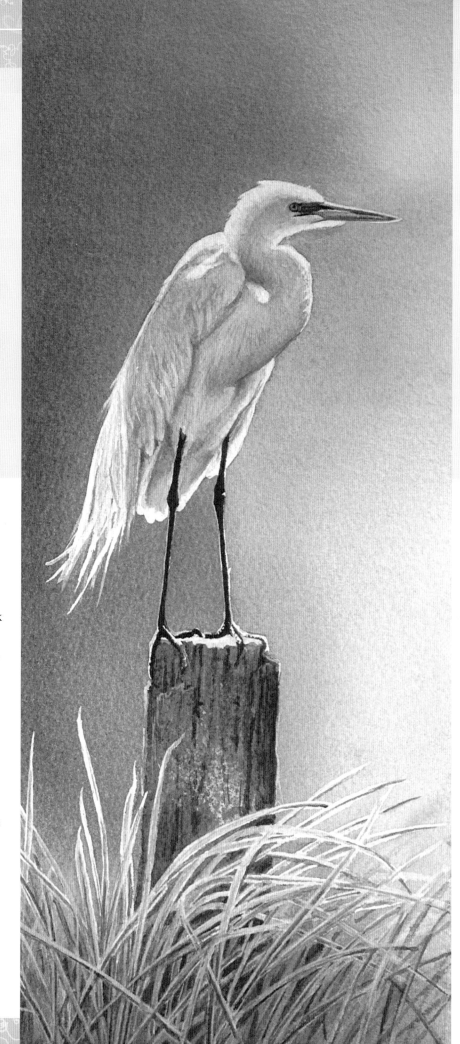

4 ADD FINAL DETAILS

Use a no. 2 round and a light Payne's Gray–Burnt Sienna mix to add feather details to the wing and neck. Use a very dark mix of these same two colors for the legs and feet, leaving a few white highlights. Add some bark texture to the stump with the same mix. Paint the beak and eye area with pale New Gamboge, leaving the top edge and the edge of the tip white. Dry. Paint the darker areas behind the beak and along the lower edge and tip with Burnt Sienna, again leaving the white edge. Add some strokes of Burnt Sienna to the grasses, leaving the edges of the top grasses light. Dry. Detail the eye with dark Payne's Gray.

APPROACHING STORM
Egret
Watercolor on 300-lb. (640gsm) Arches
 cold-pressed paper
13" x 7" (33cm x 18cm)

DEMONSTRATION
Backlit Leaves

In this small study, the focus is the dry oak leaves clinging to branches in winter. The backlighting changes their ordinary brown color to gold.

1 DRAW AND MASK, THEN PAINT THE BACKGROUND

Draw the shapes on the paper, then spray with workable fixative. Apply masking fluid to the foreground with a no. 4 synthetic round. Dry.

Mix a medium-size puddle of Payne's Gray and a small puddle of Burnt Sienna. Using a 1-inch (25mm) flat, paint the background with the gray, leaving the right-side corners a bit lighter. Just before the shine leaves this wash, paint in a few soft leaf shapes with a no. 6 round and Burnt Sienna. Dry, then remove the mask.

2 PAINT THE BRANCHES

Avoiding the snow patches, paint the foreground branches and twigs with Payne's Gray and a no. 6 round, leaving the edges white to indicate backlighting. Use this mixture to paint the space between the branches under the bird. For the lichen areas, detail the bottom edges with a no. 2 round by painting the dark bark behind the lichen fibers. Paint the more distant branches with a diluted Payne's Gray, but do not leave a white edge on these branches.

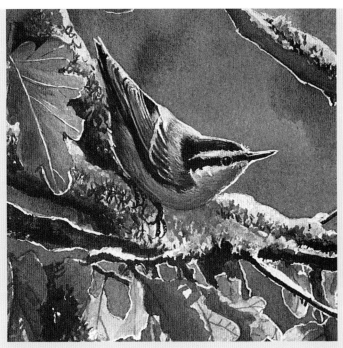

3 **PAINT THE LEAVES AND LICHEN**
Mix Payne's Gray and just a touch of Naples Yellow for a medium gray-green. Using a no. 2 round, paint some squiggles on the lichen areas, leaving the top edge white. Dry. Dilute the mix to a light value and use a no. 6 round to lightly glaze the lichen area. Dry. Mix Burnt Sienna and Payne's Gray to a medium value. Apply to the lower edges of the lichen, pulling up to give it a rounded shape.

Prepare a golden mix of Naples Yellow and New Gamboge as well as a puddle of Burnt Sienna. Working on one leaf at a time, paint the entire leaf with the golden mix except for the backlit edge. Leave a round unpainted spot on one leaf. When the shine is gone, paint the rusty center area with Burnt Sienna. Dry each leaf before going on to the next.

4 **PAINT THE NUTHATCH**
Use a no. 2 round and Payne's Gray to paint the nuthatch's head, eyestripe, beak and feet, leaving an edge of bright white around the head and beak and a dot of white for the highlight in the eye. Dry.

Mix a little Cobalt Blue with Payne's Gray to make a deep gray-blue. Paint this on the nuthatch's wing and back, avoiding the highlights. Dry. Add wing details with Payne's Gray. Dry. Paint the throat and side with a mix of Burnt Sienna and just a little of the gray-blue mix, leaving a fine white edge at the throat. Dry, then add a few feather details with Burnt Sienna.

Glaze the shadowed areas of the lichen with the gray-blue mix and a no. 6 round.

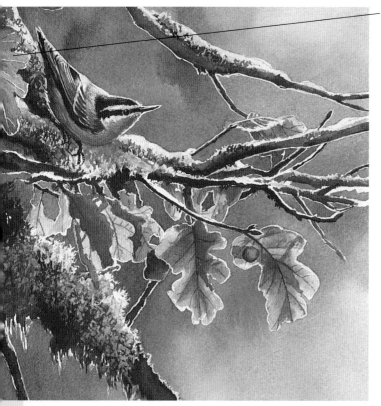

Near the end of this painting, while I was away refilling my coffee, a small disaster occurred: My cat walked on my palette and then on the painting! I lifted as much of the spot as I could, dried it, then painted a leaf with a mix of bleedproof white and New Gamboge. I dried it again, then added some Burnt Sienna details. Lesson learned: Never leave an unattended pet in the studio!

5 PAINT SHADOW AREAS AND VEINS ON THE LEAVES

Paint the shadow areas and veins on each leaf with a mix of Burnt Sienna and Payne's Gray, using a no. 2 round. Using a very dark mix of Burnt Sienna and Payne's Gray, detail the lichen patches and paint the small round gall (galls are leaf tumors caused by wasps; if you forget that, they're rather pretty).

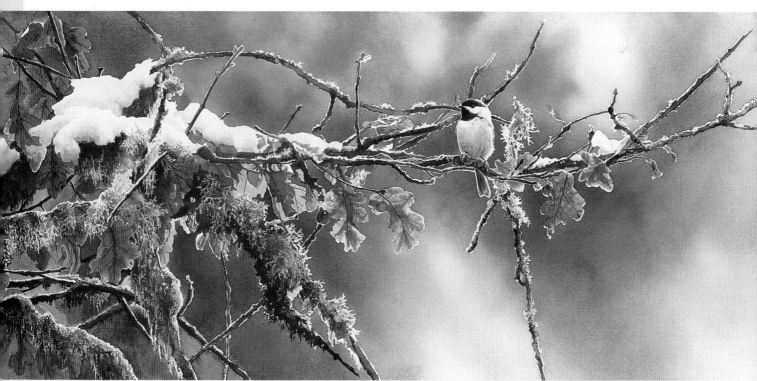

Backlit Leaves in a Larger Painting
This painting carries the idea of backlit oak leaves a little further.

NOVEMBER LIGHT
Chickadee
Watercolor on 300-lb. (640gsm) Arches cold-pressed paper
12" x 28" (30cm x 71cm)

DEMONSTRATION
Side Light

In this composition, the light is the soft light of a spring morning. The two woolly pals, so different in coloration, make a good study of how the light defines forms and how a slight change in stance can change the play of light.

MATERIALS

Watercolors
Burnt Sienna • Cobalt Blue • Naples Yellow • New Gamboge • Payne's Gray • Sap Green

Gouache
White Designer's Gouache

Paper
300-lb. (640gsm) cold-pressed, 9" x 11" (23cm x 28cm)

Brushes
1-inch (25mm) flat • Nos. 2 and 6 round

Other Materials
Masking fluid • Workable fixative

1 DRAW AND MASK, THEN PAINT THE BACKGROUND

Draw on the composition, spray with workable fixative and apply masking fluid to the foreground, including the daffodils and their leaves and stems. Using a 1-inch (25mm) flat, paint the background with a soft Sap Green–Payne's Gray mix, making the wash lighter and grayer as you work up. Use a darker green-gray where the lambs' shadows fall. Dry, then remove the mask.

Paint the daffodil leaves with very light Sap Green. Dry. Paint the daffodils, using a very pale New Gamboge for the petals. Dry again. Paint the centers with darker New Gamboge.

Use a medium-value Sap Green and a no. 2 round to paint some grass blades. Dry. Use a no. 2 round to add touches of New Gamboge in the background to suggest flowers.

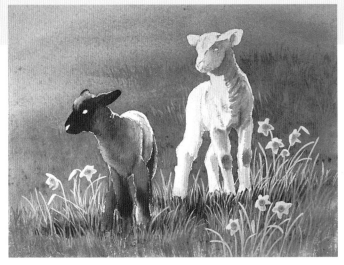

2 PAINT THE BASE WASHES ON THE LAMBS

Dark lamb: Prepare two mixtures of Payne's Gray and Burnt Sienna, one nearly black and another dark brown. Using a no. 6 round, paint the lamb with the brown, avoiding the highlights. When the brown has just lost its shine, paint the face, neck and legs with the darker mixture, concentrating on shadow areas and avoiding the highlights. For texture, dab on a bit of color as the undercoat begins to dry. Dry. Save the color mixtures.

White lamb: Prepare a Payne's Gray–Cobalt Blue mix and a light Burnt Sienna–Payne's Gray mix. Paint the shadow side of the lamb with the blue-gray, avoiding the highlight areas. When the blue-gray has just lost its shine, paint the darker shadow areas with the gray-brown, dabbing here and there for texture. Using very pale Naples Yellow, glaze the highlight area on the lamb. Dry. Save the color mixtures.

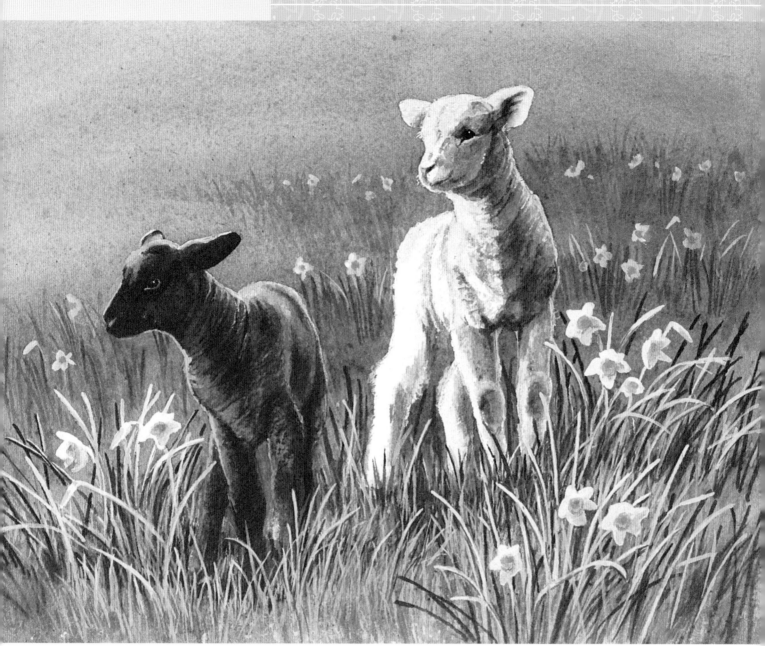

3 BUILD UP VALUES AND ADD FINAL DETAILS

Use a no. 2 round to paint the eyes with Payne's Gray, leaving a tiny white highlight. Continue to build up the shadow areas on both lambs with the same colors used in Step 2. Dry.

Glaze the highlight areas on the dark lamb with Naples Yellow that is somewhat darker than what you used for the white lamb in Step 2. Add a touch of very light Burnt Sienna just under the white lamb's nose. Use the gray-blue mixture to paint shadows under the right side of each daffodil center. Paint some shadows on the leaves and grasses with dark Sap Green.

Using a no. 2 round, paint some daffodils in the background with a mix of white Designer's Gouache and New Gamboge. Dry. Add touches of dark New Gamboge in the centers.

SPRING MORNING
Lambs
Watercolor on 300-lb. (640gsm) Arches
 cold-pressed paper
9" x 11" (23cm x 28cm)

DEMONSTRATION
Light on Water

Light is tricky enough on a three-dimensional shape, but when you want to paint light on a shimmery, shifting liquid surface, you face a real challenge. Obviously, still water is the easiest, paintable with simple wet-into-wet washes. In this puffin study, the bird is creating rings of ripples around him, which are tricky to paint. Look carefully at the patterns, the reflections and, most critically, the plane of the water.

MATERIALS

Watercolors
Burnt Sienna • Greenish Yellow • Naples Yellow • Permanent Violet • Permanent Yellow Lemon • Payne's Gray • Permanent Yellow Orange

Gouache
White Designer's Gouache

Paper
300-lb. (640gsm) cold-pressed, 8" x 14" (20cm x 36cm)

Brushes
1-inch (25mm) flat • Nos. 2, 4 and 6 round • No. 4 synthetic round for masking

Other Materials
Electric eraser or very fine finishing sandpaper

1 DRAW AND MASK THE COMPOSITION

Draw and mask the puffin, his reflection and the pattern of ripples in the water. Draw the puffin, including face and feather details, with darker lines, and draw the water ripples with lighter lines. Don't spray with workable fixative; you won't want pencil lines showing in the water area.

2 PAINT THE WATER WET-INTO-WET

Mix a puddle of dark Payne's Gray and a smaller puddle of Greenish Yellow. Using a 1-inch (25mm) flat, wet the painting and paint the water area, applying the Payne's Gray to the background and lower right corner and the Greenish Yellow to the right of the puffin. Think about water as you paint, leaving some light streaks and working in a pattern consistent with the ripples. Dry.

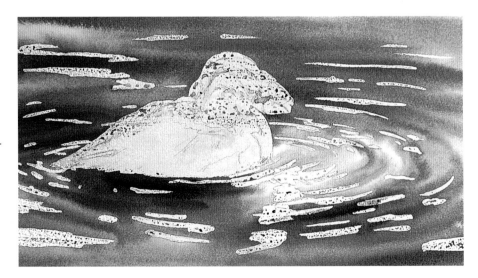

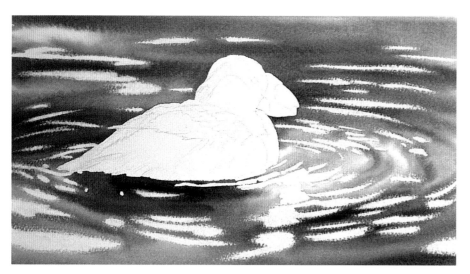

3 UNMASK, THEN SOFTEN THE RIPPLES

Using an electric eraser or fine sandpaper, gently abrade the upper and lower edge of each ripple just until the edges are soft. Be careful not to rub so hard that you damage the paper.

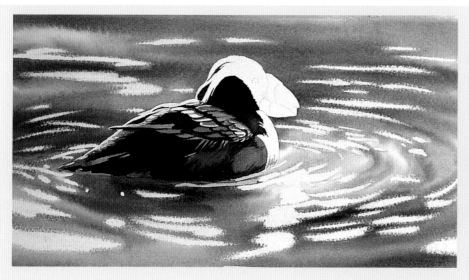

4 PAINT THE PUFFIN'S DARK PLUMAGE

Using a no. 4 round, paint the dark areas of the puffin's plumage with rich Payne's Gray, omitting the highlight areas. Dry. Dilute the Payne's Gray to a light value and mix in a touch of Permanent Violet. Glaze the highlight areas on the bird's black plumage, leaving bright white highlights on a few back feathers. Save the light wash color on your palette. Dry. Paint the feather shadows and details with dark Payne's Gray.

5 GLAZE THE RIPPLES AND PAINT THE BEAK

Using a no. 8 round and the saved light violet from Step 4, glaze the background ripples in the upper third of the painting. Dry.

Use a no. 4 round to paint the upper beak with Permanent Violet and the lower part with Permanent Yellow Lemon, leaving the top edge white. Dry. Detail the top of the beak with a darker value of Permanent Violet. For the lower part, apply Permanent Yellow Orange to the center part of the beak, pulling out but not covering the lighter yellow. Dry. Save the yellow and orange.

6 PAINT THE REFLECTION AND FACIAL DETAILS

Paint a reflection directly below the beak. Using a no. 4 round, first paint the reflected shapes with Permanent Yellow Lemon, then paint and pull out the center areas with Permanent Yellow Orange. Dry. Shade under the eyelid and paint the line of the mouth with Burnt Sienna. Also shade the underside of the beak by applying Burnt Sienna to the bottom edge and pulling up. Dry. Paint the iris of the eye with a pale mix of Payne's Gray and Permanent Violet, leaving a white highlight. Dry. Paint the pupil with dark Payne's Gray. Glaze the top-knot feathers with Naples Yellow. Using a no. 2 round, add a few details of white Designer's Gouache to the water in front of the puffin.

On some of the smaller highlights nearest the puffin, paint fine lines of light Payne's Gray to indicate reflections.

Water Creates Patterns of Light and Dark
In this painting, the water is painted with a simple charged wet-into-wet wash. Notice that the water is not all one value; it is darker in the foreground and very gradually lightens. This automatically gives the dark area more visual weight and establishes the plane of the water and the viewer's perspective looking across, not down at, the pond. To complicate matters, the reflective water makes one abstract pattern and the lily pads another. It was essential to make the foreground leaves larger and rounder and the background leaves smaller and more oval (but not too small or too oval) to establish them as being on the same plane and being viewed from the same perspective as the water.

MIRROR POND
Green-backed Heron
Watercolor on 300-lb. (640gsm) Arches
 cold-pressed paper
20" x 15" (51cm x 38cm)

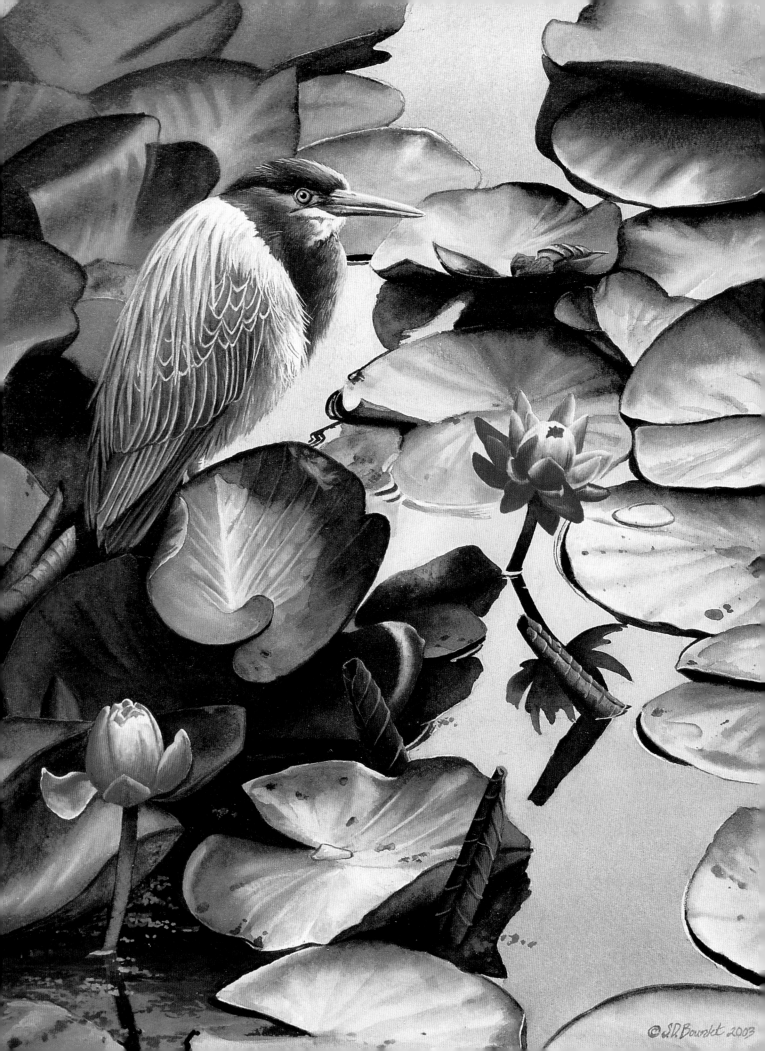

© S.D.Bourket 2003

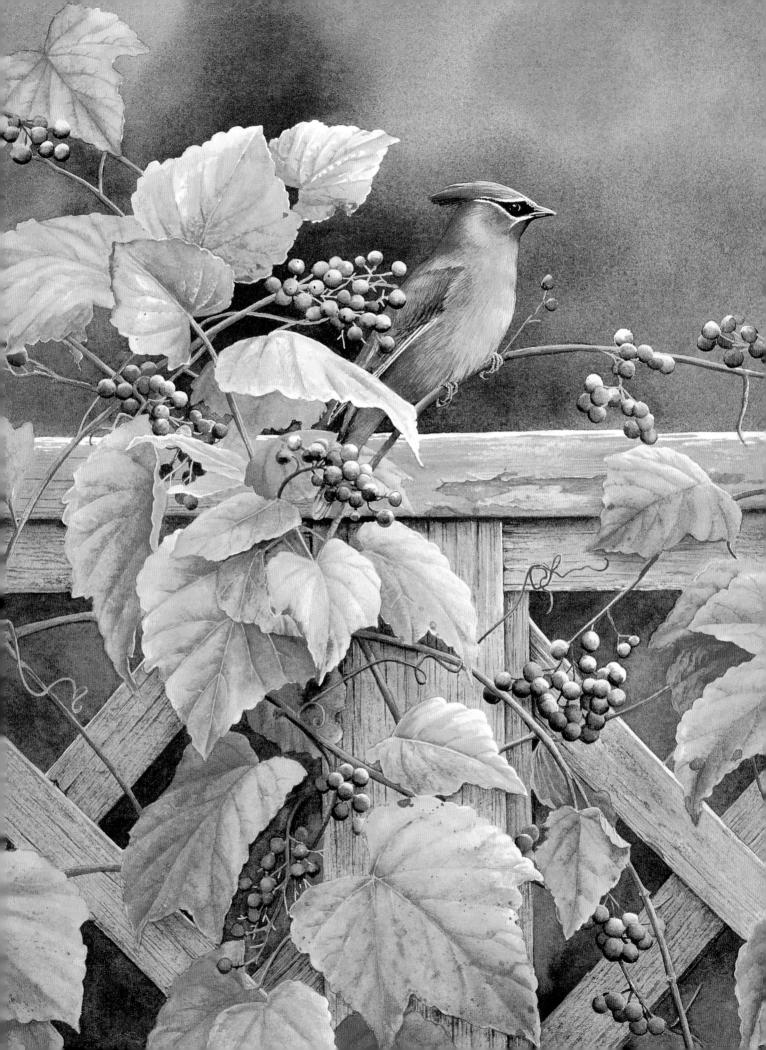

5

CREATING TEXTURES WITH LIGHT

*T*exture details are great fun to paint, and nearly every artist is tempted to rush ahead to get to the fun part. But before you add surface character, you must establish a foundation of correct form and value. If the initial values are weak, you'll end up painting over your first strokes repeatedly in an effort to correct the form. A formless animal will not look rounder just because you've given him a coat.

Once you've established form and value successfully using the techniques you've learned in the previous chapters, you'll find that you need only suggest the surface characteristics with simple strokes. By studying the patterns of highlight and shadow on textured surfaces, you'll soon figure out how to paint them by suggesting details and emphasizing lighting. In this chapter, we will look at different kinds of surfaces and learn how to use the basic watercolor techniques as well as some "special effects" to make the textures in your paintings look real.

COUNTRY GARDEN
Cedar Waxwings
Watercolor on 300-lb. (640gsm) Arches cold-pressed paper
22" x 16" (56cm x 41cm)

DRYBRUSH-OVER-WASH
Aspen and Birch Bark

Natural surfaces like mossy rocks, bark and weathered wood may look detailed but can be simulated with techniques like drybrush, spatter and salting. What you want for these kinds of surfaces is a random, irregular pattern rather than painted-on details.

For this drybrush-over-wash technique, you'll pick up color with a damp no. 8 round and drag the side of the brush lightly over the area to be painted so that the color is applied just to the bumps of the paper. The more pressure you use, the more color will be deposited.

MATERIALS

Watercolors
HOLBEIN: Burnt Sienna • Compose Green #3 • Green Gold • Naples Yellow • Payne's Gray • Permanent Violet

Paper
300-lb. (640gsm) cold-pressed, 4" x 8" (10cm x 20cm)

Brushes
1-inch (25mm) flat • Nos. 4 and 6 rounds • No. 4 synthetic round for masking

Other Materials
Masking fluid • Tissues

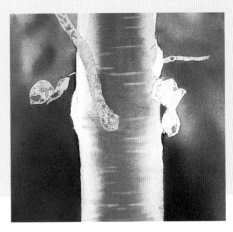

1 DRAW AND MASK, THEN PAINT THE BACKGROUND
Sketch the composition on your paper. Mask any branches and leaves that extend over the background or the tree trunk. Use a 1-inch (25mm) flat to paint the wet-into-wet background with a dark blend of Payne's Gray and Compose Green #3, lightening at the top to Green Gold and Naples Yellow. Dry.

2 LAY IN BASE WASHES
Use a no. 8 round to paint the left edge of the tree trunk pale Naples Yellow, pulling the color out to avoid a hard line. With the same brush, lightly wet the tree trunk and then paint the middle area of it with a medium-density mix of Payne's Gray and Permanent Violet. While the wash is still wet, pull some color in bands into the lighter-colored edge areas. Save some of this color on your palette. Dry until the paper is barely damp, then proceed to the next step.

3 LIFT OUT LIGHT BANDS
When the painting is barely damp, use a wetted no. 4 round to lift out little bands of color here and there on the tree trunk, scrubbing lightly with the wet brush and then blotting with a dry tissue. Dry.

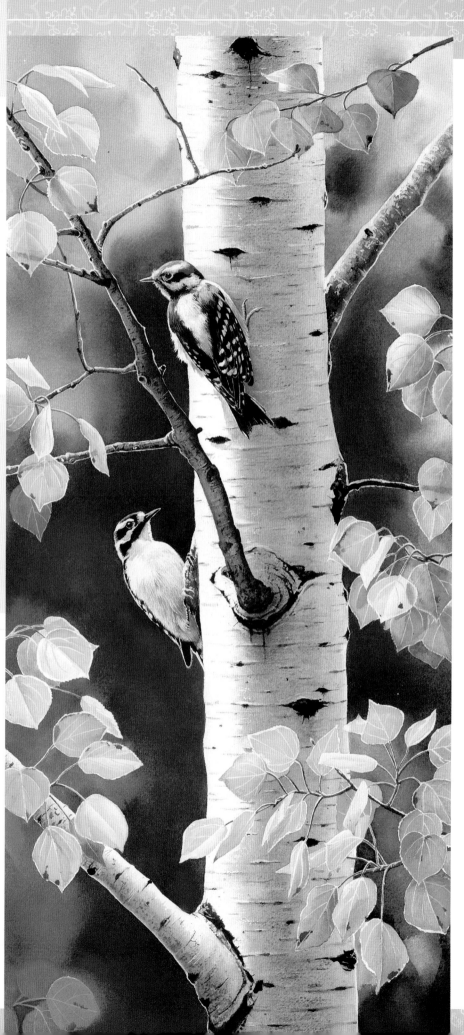

The Finished Aspen Painting

In this painting, I used the same bark technique. I chose a long, narrow composition to accentuate the vertical lines of the aspen. Soft light filters through the forest canopy above, so the cool, violet shadows are also soft and needed to be consistent throughout the painting.

AUTUMN GOLD
Downy Woodpeckers
Watercolor on 300-lb. (640gsm) Arches
 cold-pressed paper
28" x 12" (71cm x 30cm)

4 PAINT THE "EYES" AND DETAILS

Use a no. 4 round and a Payne's Gray–Burnt Sienna mix to add some lines and blotches of black under the pulled-out light bands for the "eyes." Drybrush the black lightly over the shaded area of the trunk with a barely damp no. 8 round, then drybrush a little of the saved gray-violet on the light areas of the trunk.

DRYBRUSH-OVER-WASH
Weathered Wood

For aged wood, the drybrush-over-wash technique is used again, but this time the color is picked up on the tip of a wetter no. 8 brush and dragged down the paper in the direction and pattern of the woodgrain, making streaks instead of depositing on the paper bumps. To make the texture more realistic, fan out the bristles and drag the brush in parallel strokes.

MATERIALS

Watercolors
HOLBEIN: Burnt Sienna • Cobalt Blue • Naples Yellow • Payne's Gray

Paper
300-lb. (640gsm) cold-pressed, 8" x 10" (20cm x 25cm)

Brushes
1-inch (25mm) flat • Nos. 2 and 8 round • No. 4 synthetic round for masking

Other Materials
Masking fluid (optional) • Old toothbrush • Paper towels

1 DRAW AND MASK, THEN PAINT THE BACKGROUND

Sketch the composition on your paper. Mask the flowers and leaves. Mix puddles of Payne's Gray and Naples Yellow on your palette. Using a 1" flat, paint the wet-into-wet background, keeping a lighter area at the upper left corner and allowing the two colors to blend softly on the paper. Dry.

2 APPLY THE BASE WASH

Apply a silvery base wash mixture of Payne's Gray and Cobalt Blue with a 1-inch (25mm) flat. Dry.

3 DRYBRUSH THE WOOD GRAIN

Add a little Burnt Sienna and more Payne's Gray to make a darker gray. Drybrush the wood grain and paint the knothole, using the slightly splayed tip of a no. 8 round.

4 SPATTER, THEN PAINT THE DETAILS

Cover the background and highlight areas with paper towels, then use a toothbrush to lightly spatter the wood. Dry. Use a no. 2 round to paint the cracks and other fine details. Dry. Remove the mask.

GOLDEN AFTERNOON
American Goldfinch
Watercolor on 300-lb. (640gsm) Arches
 cold-pressed paper
23½" x 8⅞" (60cm x 23cm)

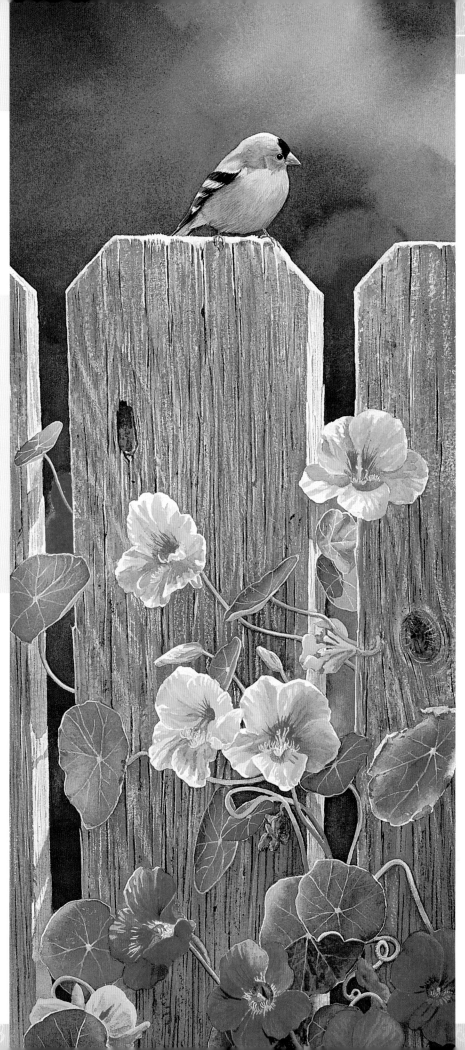

SALT TECHNIQUE
Mossy Rock Wall

I chose the salt technique for this stone wall because the ragged pattern created by the salt crystals reminds me of lichen-covered rock. Results when using salt will depend on how wet the wash is when you apply the crystals and how large the salt crystals are. In this case, I wanted small, well-defined shapes, so I used table salt.

MATERIALS

Watercolors
HOLBEIN: Burnt Sienna • Cobalt Blue •
Compose Green #3 • Green Gold •
Naples Yellow • Payne's Gray

Paper
300-lb. (640gsm) cold-pressed, 8" x 10"
(20cm x 25cm)

Brushes
1-inch (25mm) flat • Nos. 2, 4 and 6 rounds

Other Materials
Table salt

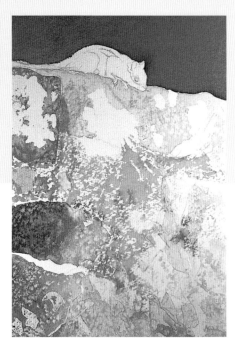

1 DRAW AND MASK, THEN PAINT THE BACKGROUND

Sketch the composition on your watercolor paper. Mask the chipmunk, leaves and light lichen patches and let dry thoroughly. Use a 1-inch (25mm) flat to paint the wet-into-wet background with Payne's Gray, changing to Green Gold on the left side. Dry.

2 PAINT AND SALT THE ROCKS

Working one rock at a time, use a no. 8 round to paint the rocks with varying mixes of Payne's Gray, Cobalt Blue and Burnt Sienna. When the shine has barely left each wash, sprinkle the area randomly with table salt. Dry naturally, without the hair dryer.

3 DRYBRUSH THE MOSS

Use a no. 8 round and Green Gold to drybrush the moss, leaving plenty of white paper for highlights.

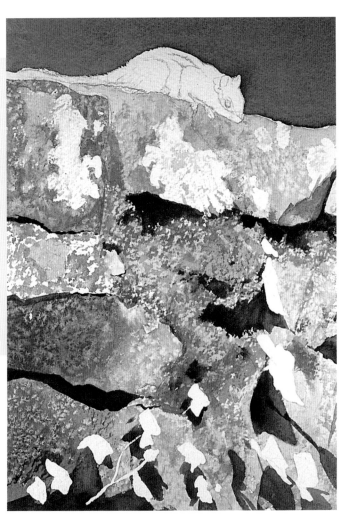

4 BUILD UP THE MOSS TEXTURE AND VALUES

Use a no. 8 round and a darker mix of Green Gold and Payne's Gray to drybrush the moss a second time. Use a no. 6 round and Payne's Gray to paint the cracks and the leaf shadows. Remove the mask.

5 PAINT THE LEAVES, DETAILS AND CHIPMUNK

Use a no. 4 round to add darker details to the moss. Paint the ivy with Compose Green #3, leaving white lines for veins and making the sunlit leaves lighter. Start the chipmunk with a wash of Naples Yellow, then pull up toward the highlights with Burnt Sienna, leaving the highlights very light and the stripes white. Paint the eye with Payne's Gray and a no. 2 round, conserving the highlight. Add a little fur texture with mixes of Burnt Sienna and Naples Yellow for the lights and mixes of Payne's Gray and Burnt Sienna for the darks. Paint the chipmunk's shadow with a Payne's Gray–Cobalt Blue mix, pulling out slightly to gradually lighten the value in the lower part of the shadow.

Terra Cotta Flowerpots

Like the stones of the rock wall, the texture of terra cotta begins with base washes using granulating pigments, like Burnt Sienna and Cobalt Blue. This combination naturally creates a grainy effect, which can be enhanced with drybrush. Lime deposits and algae, painted like the lichen patches on the rock wall, add some "gritty reality."

MATERIALS

Watercolors
HOLBEIN: Burnt Sienna • Greenish Yellow • Naples Yellow • Payne's Gray • Yellow Ochre

Paper
300-lb. (640gsm) Arches cold-pressed, 5" x 8" (13cm x 20cm)

Brushes
1-inch (25mm) flat • Nos. 4 and 6 round

1 PAINT THE BACKGROUND

Use a 1-inch (25mm) flat to paint the background with a mix of Payne's Gray and Burnt Sienna, lightening gradually on the right side.

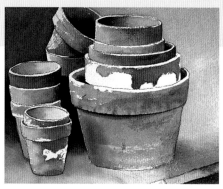

2 PAINT THE FLOWERPOTS WITH WARM WASHES

Use a no. 8 round to paint the flowerpots, one at a time, with varying mixtures of Burnt Sienna and Yellow Ochre, avoiding the rims and lichen spots. The light is soft in this composition, but be sure to pull the color out to show form. Keep the left side very light, darkening gradually to make the pot look round. Dry.

3 PAINT THE SOFT SHADOWS, THEN DRYBRUSH

Re-wet the lower part of the large pot, then use a cool mix of Payne's Gray and Burnt Sienna to paint the shadow of the little pot, pulling out to give the shadow a soft edge. Dry. Drybrush the pots lightly, using mixtures slightly darker than their base coats. You can even use a little Greenish Yellow here and there to simulate moss.

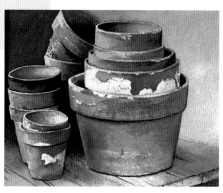

4 PAINT THE RIMS AND SHADOWS

Paint the rims with very light Burnt Sienna mixes, using the no. 4 round. Paint the shadows under the pots with Payne's Gray.

SALT TECHNIQUE
Watering Can

For texture on an old watering can, salt is a useful tool. Added when the base wash is just barely losing its shine, the salt creates a patchy texture. With some streaks of rust added, the watering can looks convincingly aged.

MATERIALS

Watercolors
HOLBEIN: Burnt Sienna • Cobalt Blue • Payne's Gray • Yellow Ochre

Paper
300-lb. (640gsm) cold-pressed, 8" x 10" (20cm x 25cm)

Brushes
1-inch (25mm) flat • Nos. 4 and 8 round

Other Materials
Table salt

1 DRAW, PAINT BASE COAT AND CREATE SALT TEXTURE

Sketch the composition on your paper. Use a no. 8 round to paint a base coat of silvery gray on the body of the can with a mix of Payne's Gray and Cobalt Blue. Soft light comes from the upper left, so pull color out to leave the left side light and darken gradually to the right. When the shine just starts to disappear, sprinkle on salt. Let dry naturally. Repeat for the spout (and also for the handle, though the base wash on the handle is not shown here), leaving the upper edges light.

2 PAINT THE HANDLE, SUN-LIT TOP AND RUSTY AREAS

Use a no. 4 round to add rust streaks to the body of the can by painting in a stroke of Burnt Sienna, then pulling out with clear water. Also paint the threaded part of the spout and add a few rust spots around the rim. Paint the top of the can using a very light Yellow Ochre and concentrating the color on the near edge. Paint details on the spout and handle with dark Payne's Gray.

Another Use of Salt
This painting shows another use of the salt technique. I broke pieces of rock salt with a hammer to a size of about one-eighth inch. Instead of randomly sprinkling the pieces, I used tweezers to place them.

SNOW QUEEN
Snowy Owl
Watercolor on 300-lb. (640gsm) Arches cold-pressed
22" x 30" (56cm x 76cm)
Collection of Mr. and Mrs. Gary Davis

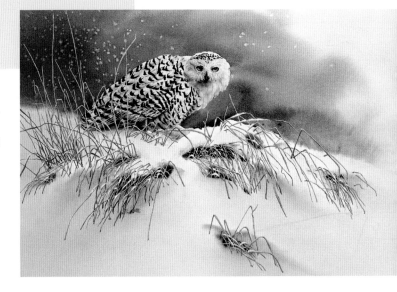

Leaded Glass Window

When I saw the wisteria blooming in front of these wonderful old leaded glass windows, I knew I had to do this painting. Window glass is really just a matter of painting what the glass reflects. In this case, some of the decorative panes were actually jewel-cut, so each one had to be treated as a little charged wash.

<div style="border:1px solid">

MATERIALS

Watercolors
HOLBEIN: Burnt Sienna • Cobalt Blue • Compose Green #3 • Mineral Violet • Payne's Gray • Permanent Rose • Permanent Violet

Paper
300-lb. (640gsm) cold-pressed, 4" x 8" (10cm x 20cm)

Brushes
Nos. 2 and 4 round

</div>

1 PAINT THE UNDERWASHES

Premix three puddles using Payne's Gray as a base: one tinted with Compose Green, one with Permanent Violet and one with Permanent Rose. Next, with a no. 4 round, paint a very pale mix of Payne's Gray and Cobalt Blue wet-on-dry on each section of glass, one section at a time, avoiding the highlights. While the section is still wet, charge in your three premixed colors. For good control, finish one section, including the charged colors, and then dry it before continuing to another section.

2 BUILD UP REFLECTIONS WITH DARKER WASHES

One at a time, re-wet the upper sections and build up the reflections to the right value. Dry.

3 PAINT THE LEAD DIVIDERS

Mix puddles of Payne's Gray, Yellow Ochre and Mineral Violet. Use a no. 4 round and varying combinations of the three colors to paint the lead dividers. Dry. Line the edges with Payne's Gray, using a no. 2 round.

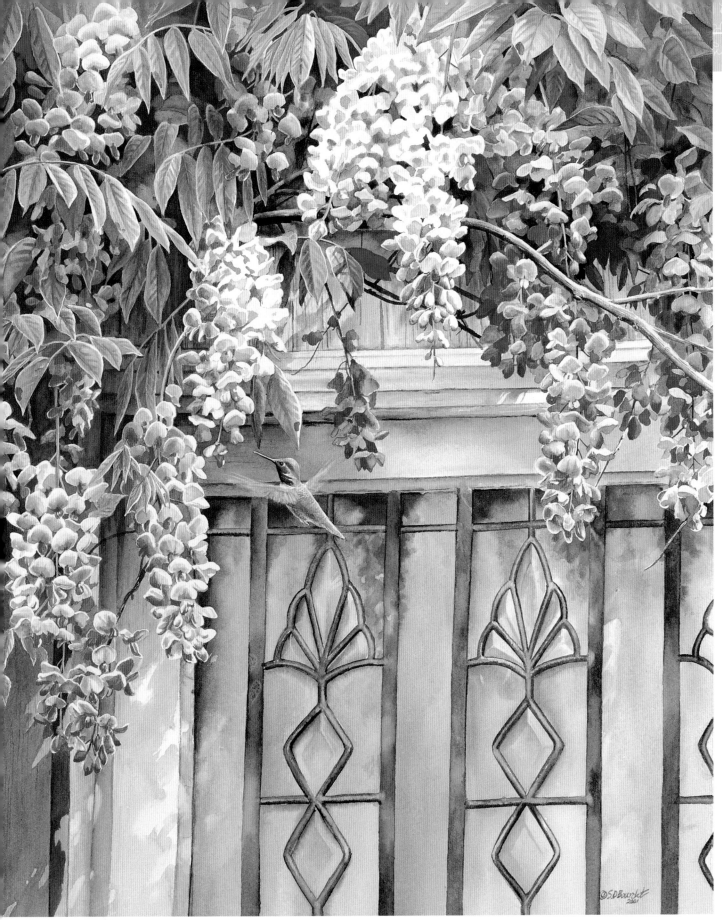

Finished Painting
In the final work, the leaded glass window is draped with wisteria flowers.

LAVENDER CURTAIN
Calliope Hummingbird
Watercolor on 300-lb. (640gsm) Arches cold-pressed paper
28" x 22" (71cm x 56cm)

BUILDING UP
Winged Garden Insects

For challenging textures, just look to living things—flowers and leaves, birds and bugs and everything furry or feathered. Like everything else, though, begin with base washes, establish the form and then build the details on top. If you mix in some dramatic lighting, it all falls into place.

Let's look first at crawly critters. You can see that a dragonfly, a bee and a butterfly all go through the same metamorphosis when painted. Begin with a light wet-on-dry base wash, keeping the lights and preserving the highlights, either by painting around them or by masking. Then build up with a second wash, again keeping the lights and highlights.

 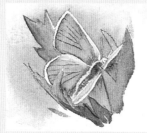 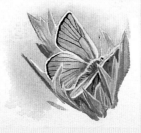

The Butterfly Wings
The butterfly is also done using charged washes—Cobalt Blue and Permanent Rose. It's a project very much like the leaded glass window on page 92, only much smaller. Here the veins are painted with a no. 1 round and Payne's Gray and the antennae are scratched out.

Small, But Complicated
The bee, being tiny and having a bunch of different textures, is the most challenging. Start with underwashes, then build up the values and paint in a few "fur" details. Pulling fine, short lines of the background purple into the Permanent Yellow Lemon of the body creates the fuzzy edges. It's important to keep the highlights on the shiny surfaces—wings, legs, top of thorax and eyes. Pick them out with a sharp craft knife to add sparkle.

Charged Washes on the Dragonfly Wings
Like the windowpanes in the project on page 92, the wings of the dragonfly are painted one at a time with charged washes for a transparent effect, except that this time you are seeing through the wings to the color behind. All of the wing values need to be kept lighter than the background for good contrast. The light sparkle and the tiny veins segmenting the wings can be delicately scratched out with a sharp craft knife.

94

TINTED WHITE GOUACHE

Soft Fur

For this little kitten study, the background window is painted the same way as the leaded glass window on page 92, beginning with a light gray wash and then charging in the greens and light violets. To keep the strong sense of sunlight coming through the window, the right corner is kept quite light but needs enough value to define it from the fur. Masking is important here, as the fuzzy edge of the cat's fur and the crisp edge and border of the curtain need to be the bright white of the paper. If the masking is executed carefully, much of the work of this painting is done—those ragged edges describe the textures. It is essential to keep the quality and direction of the light consistent throughout the whole study.

For believable fur, I used white Designer's Gouache tinted with watercolor to add surface fuzz. Although it should not be overdone, this technique creates the illusion of a soft, thick coat.

MATERIALS

Watercolors
HOLBEIN: Burnt Sienna • Cobalt Blue • Compose Green #3 • Mineral Violet • Naples Yellow • Payne's Gray • Permanent Rose • Permanent Violet • Sap Green

Gouache
White Designer's Gouache or bleedproof white

Paper
300-lb. (640gsm) cold-pressed, 8" x 10" (20cm x 25cm)

Brushes
1-inch (25mm) flat • Nos. 2, 4 and 6 round

Other Materials
Masking fluid

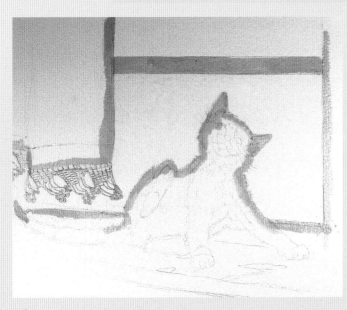

1 DRAW AND MASK
Draw and then carefully mask the edges of the window frame, the kitten and the curtain.

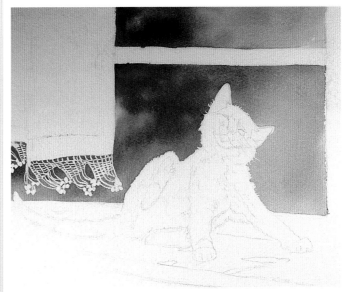

2 PAINT THE WET-INTO-WET BACKGROUND
Using a 1-inch (25mm) flat, paint the background with a charged wet-into-wet wash of Payne's Gray, Permanent Violet, Compose Green #3 and Sap Green. Mix the gray and violet into the green to soften the colors. Dry. Remove the mask.

Rules of Thumb for Painting Fur
- Carefully observe the sunlight and shadow patterns.
- Details at the transition edges between sunlit and shaded areas are the most important, so draw and paint those carefully.
- Outside edges need to reveal the fluffiness or smoothness of the coat. The easiest way to show that is use plenty of contrast.

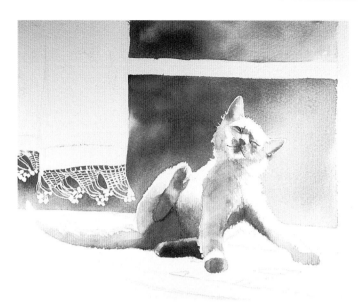

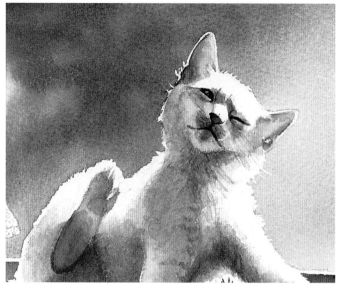

3 PAINT THE SHADOW AREA

To establish backlight on a white subject, the core shadow must be fairly dark. Using a no. 6 round, paint shadow areas with a mix of Mineral Violet and Payne's Gray. At the edges of the shadow, pull some hairlike strokes into the white. Dry.

Paint a band of Naples Yellow on the flank, shoulder, cheeks and chest, blending the color at the edges. (This warm yellow band is critical to creating the backlit effect.) Paint the insides of the ears. Dry. Mix a little Burnt Sienna into the Payne's Gray–Mineral Violet mix and paint the darkest areas. Pull out a few lines of this color into the lighter gray. Use a darker mix of the same colors to paint the eyelids, nose and mouth.

4 BUILD UP THE WASHES AND ADD DETAILS

Continue to build up the washes, making the center core area darker and pulling lines of darker color out at the edges to add texture. Mix a little Permanent Rose with Naples Yellow to make an apricot color. Paint the outer edges of the ears, pulling in for a soft blend. Dry. Paint in a few delicate veins where the ears are backlit. Add some strokes of apricot color to the Naples Yellow areas and also tint the corners of the mouth and the right side of the nose.

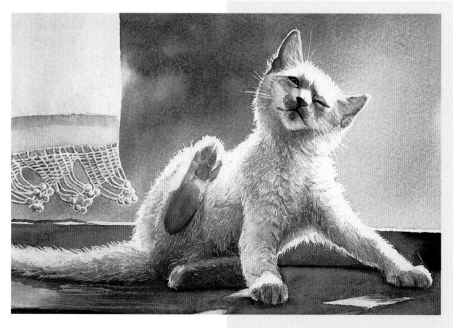

5 PAINT THE LACE CURTAIN WASHES AND THE WOOD

Make a light-value mix of Payne's Gray, Mineral Violet and Naples Yellow. Using a no. 6 round, paint the hem of the curtain and the fold and also shade the lace with a few lines of detail, keeping the right side very light. Add a second coat with just a little more violet to the folded-over areas of the curtain.

Paint the light areas of the window frame with light Burnt Sienna and the no. 6 round, avoiding the highlights. Dry. At the corners and edges, add a darker Payne's Gray–Burnt Sienna mix. Dry. Mix some Cobalt Blue into the Burnt Sienna mix, then paint the cat's shadow, avoiding the bright spots of sunlight on the windowsill. Drybrush a little texture on the wood.

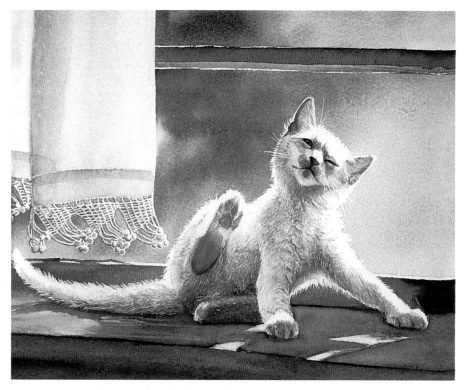

6 PAINT THE SPACES BETWEEN FUR CLUMPS

After cleaning your palette, mix a little Payne's Gray with a little diluted Permanent Violet. Following the direction of fur growth, paint inverted V and W shapes in darker areas to designate clumps of fur with a no. 4 round. Dry. Mix a little white Designer's Gouache with a tiny amount of Cobalt Blue and just enough water to make it paintable. Using a no. 2 round, paint fine hairs, being careful not to cover up the values with the lighter color. Paint a few strokes of pale gray-violet on the light fur, especially at the transition edges.

A GOOD SCRATCH
Watercolor on 300-lb. (640gsm) Arches
 cold-pressed paper
9½" x 12½" (24cm x 32cm)

Another Example of Light on Fur

I encountered this engaging leopard cub at a petting zoo in southern Oregon. He and his siblings were born in captivity and so regarded the human race as a bunch of clowns designed for the amusement of young leopards. The play got a little rough, but it was a thrill to hold him! The strong backlight on his fur was a challenge to paint because his features were in deep shadow while the fur at the edges was brightly lit. So that I could see the face in my reference photo, I took the negative back to the photo store and had them lighten it a little.

EYES OF INNOCENCE
Leopard Cub
Watercolor on 300-lb. (640gsm) Arches
 cold-pressed paper
16" x 20" (41cm x 51cm)

6 PUTTING IT ALL TOGETHER

You've come a long way since the beginning of this book: you've learned about light and color basics, paint properties, reference photography, design and composition, and how to capture various light and texture effects in a painting. Now, we'll put all of these lessons to work on several full-sized compositions. Each of the painting projects in this chapter has a different challenging subject and a different set of problems to solve.

WINDOW SHOPPING
House Wren
Watercolor on 300-lb. (640gsm) Arches cold-pressed paper
7" x 14" (18cm x 36cm)

DEMONSTRATION
A Floral Composition

For this wisteria piece, the "hook" is the complementary color scheme—soft, smoky purples and violets contrasted with clear yellows and golden-greens.

The Challenges

For a floral painting, the most difficult problem is creating a feeling of depth. To give dimension to the wisteria vines, the background and middle ground leaves and flowers had to recede. I used a wet-into-wet technique to suggest background flower and leaf forms. I softened the edges of some botanical elements and painted them in muted colors so they would appear to be behind the others. I also added a few flower clusters over the top of the background wash after it was dry, using a diluted gouache-watercolor mix. Because they were painted over a dark color and this paint mix was only partially opaque, these flowers receded very effectively, creating another compositional layer between the background and foreground.

MATERIALS

Watercolors
HOLBEIN: Bright Violet • Burnt Sienna • Compose Green #3 • Greenish Yellow • Leaf Green • Marine Blue • Payne's Gray • Permanent Rose • Permanent Violet • Permanent Yellow Lemon • Shadow Green

Paper
300-lb. (640gsm) cold-pressed, one-half sheet, 22" x 14" (56cm x 36cm)

Brushes
1½-inch (38mm) flat • Nos. 4, 6 and 8 round

Other Materials
Masking fluid • Workable fixative

WARBLERS AND WISTERIA
Wilson's Warblers
Watercolor on 300-lb. (640gsm) Arches cold-pressed paper
22" x 15" (56cm x 38cm)

Sketch

The vertical wisteria stems create diagonal movement. The horizontal stem and the pendulous flower clusters pull the viewer's eye in an oval around the painting.

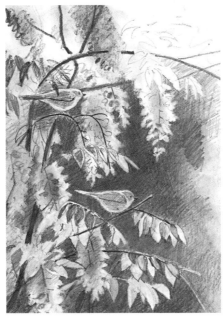

Value Study

To add interest, I placed the birds and planned the values so that one bird will be discovered right away and the other is somewhat hidden in the foliage.

Reference Photos

My flower references, taken in late afternoon, came from a friend's yard. I photographed them because I loved the "secret garden" effect of the light winking through the foliage. The shy little Wilson's warblers were photographed at a nearby refuge.

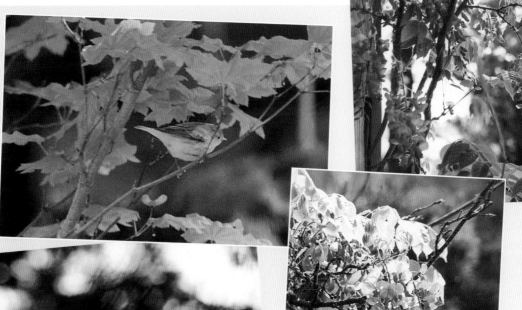

1 DRAW AND MASK THE COMPOSITION

Draw the composition on tracing paper, then use graphite paper to transfer it to the watercolor paper.

Mask as shown. Because of all the complicated shapes, you need mask only the items that overlap onto the major central wash area on the right side of the long diagonal branch.

2 START THE WET-INTO-WET BACKGROUND

Mix puddles of Shadow Green, Permanent Violet, Leaf Green and Payne's Gray on your palette. With a 1½-inch (38mm) flat, evenly wet the large area of the background, stopping at the long diagonal branch. With the same brush, pick up a pale mix of Leaf Green and pure water. Lay this in the upper right corner, letting some paper remain white to suggest light. Work down, adding diluted Permanent Violet and Payne's Gray and rinsing and blotting the brush with each color change. Leave some white areas, and occasionally repeat the green.

Make a dark Shadow Green–Payne's Gray mix. Work this in next to the long diagonal branch. Add a little Permanent Violet and continue to work downward. Tilt the paper to blend the colors.

Use a no. 8 round to suggest leaf shapes in the upper right with Greenish Yellow and, if desired, some flower shapes near the center with diluted Permanent Violet and Permanent Rose. Save your background colors for the next step. Dry, then remove the mask.

Notice that the "flag" part of each flower is paler than the lower part. Painting them this way will give definition to your flower clusters.

3 FINISH THE BACKGROUND, THEN PAINT FLOWERS AND STEMS

Working with a no. 6 round, paint in the remaining background areas using the wet-on-dry method and the saved wash colors from Step 2. Also paint the brightly sunlit negative spaces in the upper left part of the composition with a light mixture of Permanent Yellow Lemon and Greenish Yellow.

Dry the painting and clean your palette. Mix several shades of Permanent Violet on the palette, ranging from a very dark to very pale. Also mix a little Permanent Rose into some of the violet puddles so that you have some varying shades of purple and lavender. Using a no. 4 round, paint the upper flower clusters, drying each time you change shades to avoid bleeding. Use the dark violet for the shadowed foreground flowers and the pale mix for the background clusters. Paint the wisteria stems with a mix of Burnt Sienna and Permanent Violet, leaving a fine white edge along the light-facing side of each. Dry. Use the same brush to glaze the light-facing sides with diluted Burnt Sienna.

4 PAINT THE SUNLIT FLOWER CLUSTERS

Paint the sunlit flower clusters, using the lighter shades of violet and conserving the whites. Dry each time you change shades, as in Step 3. Light comes from the upper right to illuminate the tops of the flowers, so be sure to save the white flags and edges in those areas and to use a paler shade of violet for the lower petals. For the shadowy flower clumps, tone down the flags with a light glaze of violet and use deeper shades of violet and pink for the lower petals.

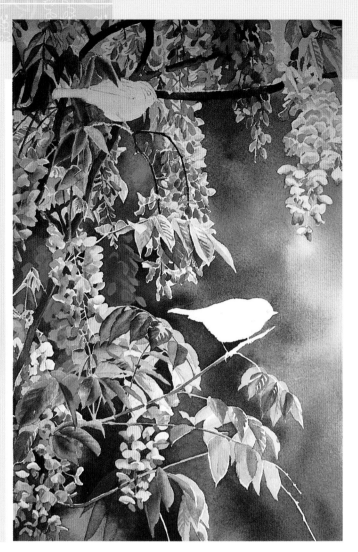

5 PAINT THE LEAVES THAT TILT TOWARD THE LIGHT

For the leaves that tilt toward the light, use a pale mix of Leaf Green and Marine Blue, leaving some white for veins and highlights. Use a darker mix of the same two colors to paint the shadows under some of the lower veins on those leaves.

6 PAINT THE TRANSLUCENT AND SHADED LEAVES

Paint the leaves in the foreground using pale Leaf Green and Greenish Yellow for the translucent background leaves and dark mixes of Shadow Green and Compose Green #3 or Greenish Yellow and Shadow Green for the shaded foreground leaves. Again, dry thoroughly every time you change colors.

7 FINISH THE REMAINING LEAVES AND FLOWERS

Using the same colors and brushes as in steps 3 through 6, paint the rest of the leaves and flowers with the same methods, being careful to observe where the light strikes the vine so that the highlight areas can be made lighter and the shadow areas darker. Make sure the backlit leaves in the lower half of the painting are much lighter and more yellow in contrast to the darker, blue-green leaves in the shadows.

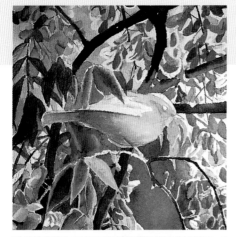

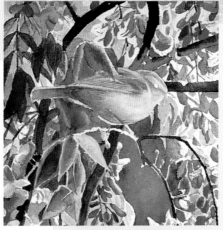

Female

9 PAINT THE BIRDS' WINGS AND THE MALE'S CAP

Use a no. 4 round and the mixture from Step 8 to paint the wings. Conserve the white highlight areas where the feather groups meet. Dry. Add a little more Payne's Gray to the mix and paint a few details on each wing. Paint the male bird's black cap with Payne's Gray, pulling out to the highlight.

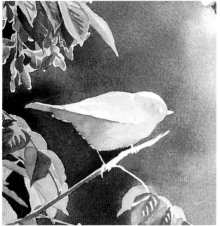

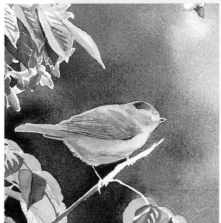

Male

8 PAINT THE BASE WASHES ON THE BIRDS

Use a no. 4 round and Permanent Yellow Lemon to paint the base washes on the birds. Pull out to the highlights and leave the wings unpainted. When the washes are barely damp, use the same brush to shade under the wings and tails with a pale mix of Burnt Sienna, Permanent Yellow Lemon and Payne's Gray. Dry. Save the colors for use in steps 9 and 10.

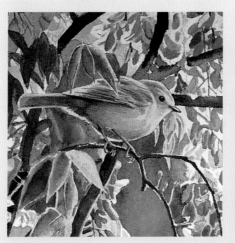

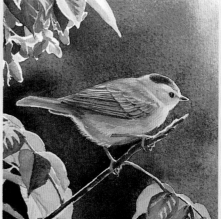

10 BUILD UP VALUES AND ADD DETAILS

Build up the values on the undersides and shadow areas of the birds, using the colors saved from Step 8, and paint final feather details on each bird. Paint the eyes with Payne's Gray, leaving a white highlight. Paint the beaks with a light glaze of Burnt Sienna, leaving a fine white edge at the tops. Dry, then paint the center part of each beak with Payne's Gray. Dry, then blend a little with a damp brush. Paint the beaks and legs with a light glaze of Burnt Sienna, leaving a fine white edge at the tops of the beaks and the fronts of the legs. Dry, then paint the center of each beak and the back of each leg with thinned Payne's Gray. Dry, then blend a little with a damp brush. Dry again, then paint the shadows on the legs with a mix of Payne's Gray and Burnt Sienna. Use a darker mix of this color to add a fine mouth line to each beak.

DEMONSTRATION
Light Through a Window

This little painting is all about light—light through glass and lace and light through soft, fluffy kitten fur. While the subject matter is simple and lighthearted, the painting presents some interesting textures that are fun to experiment with.

The Challenges

Textures are always a challenge, but when you put a bright light source behind the subject, you double the difficulty. Here, the edges of things tell a big part of the story, so the sunlit edges on both the lace and the fur needed to be kept bright white. I had to pay close attention to the anatomy of each shadow—to where the turning edges were and especially to where the core areas were. With this painting, it's easy to get lost in the details and forget that the forms will be weak if the shadow anatomies are not correct and consistent.

MATERIALS

Watercolors
HOLBEIN: Burnt Sienna • Cobalt Blue • Compose Green #3 • Leaf Green • Marine Blue • Naples Yellow • Payne's Gray • Permanent Rose • Sap Green

Gouache
Bleedproof white

Paper
300-lb. (640gsm) cold-pressed, half sheet, 22" x 15" (56cm x 38cm) • Tracing paper

Brushes
1-inch (25mm) flat • Nos. 2, 4, 6 and 8 round

Other Materials
No. 2 pencil • Masking fluid • Masking pen

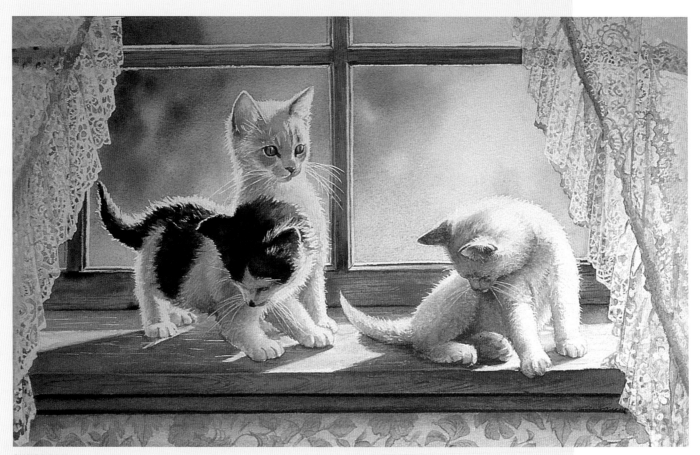

SUNBREAK
Watercolor on 300-lb. (640gsm) Arches cold-pressed paper
12" x 19" (30cm x 48cm)

Sketch
When I combine subject references or put a subject in a new context, I always do a thumbnail sketch to make sure the composition will work and hopefully to keep from making errors in the actual painting.

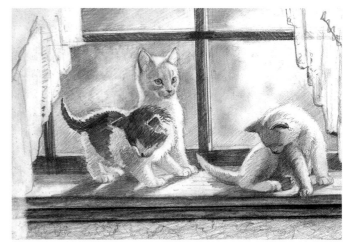

Value Study
Each reference photo was lit differently, so a value study of the composition was essential.

Reference Photos
I photographed the kittens multiple times from the same angle so the shadows would be consistent. My curtain reference showed only one side of the curtain, so I flopped the image on my computer and then imagined how the light would strike the other side.

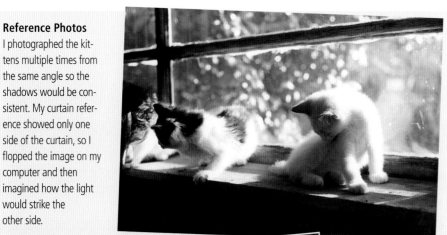

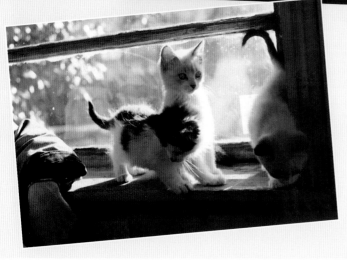

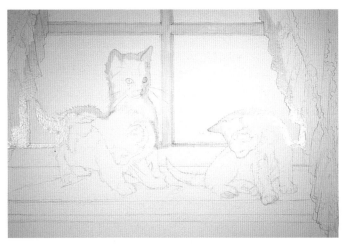

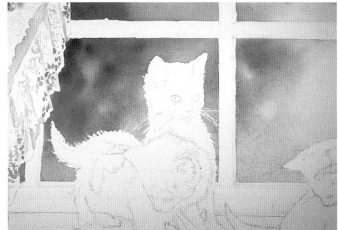

1 DRAW AND MASK THE COMPOSITION

Draw the composition on tracing paper, then transfer it to the watercolor paper. Use your pencil to lightly draw the patterns of holes, flowers and paisley in the lace, paying particular attention to the edges where the lace overlaps the windowpanes.

Mask the window mullions, the furry edges of the kittens and the lace curtain edges, leaving the holes in the curtain edges unmasked so they will fill with color. This will help simulate the pattern of lace. Use a masking pen to mask the whiskers of the middle kitten just where they overlap onto the windowpane area.

2 PAINT THE GLASS AND THE LACE BORDER

Mix puddles of Payne's Gray, Compose Green #3 and Leaf Green on your palette. Wet the left window panes, then paint them with a dark mix of Payne's Gray and Compose Green #3 and a no. 8 round. Vary the shade, making it lighter as you work left to right, and leave some lighter areas for a dappled effect. Paint into the masked edge of the lace curtain so that the "holes" fill with color.

Rinse the brush and wet the right side panes. Dilute the wash mixture a little and add a little Leaf Green. Drop this into the left corners of these panes, then work into the centers with a little very diluted Marine Blue, lightening to nearly white at the right edge. Dry. Save your colors. Remove the mask.

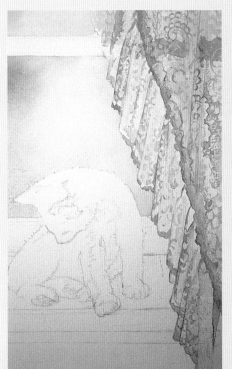

3 PAINT THE LACE USING GLAZING AND NEGATIVE PAINTING

Use a no. 4 round to paint some of the "positive" pattern areas of the lace with a light mix of Payne's Gray and just a little Permanent Rose. Also use this mixture on the folds and on the ruffles. Dry. Mix a little Burnt Sienna into the gray and use a fairly pale mix of this color combination to paint the parts of the mullions that are behind the lace curtains. Make these a little bit wavy to simulate the folds in the fabric.

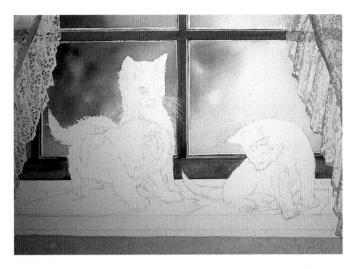

4 FINISH THE LACE AND BEGIN THE WALLPAPER

Finish the lace by painting more of the holes with the saved background colors, making sure that the color you use for each hole corresponds to the value and color of the pane behind it. Dry.

Paint the remaining parts of the mullions with a slightly darker Burnt Sienna–Payne's Gray mix, leaving the edges white. Dry, then use a no. 2 round to paint the molding at the edge of each mullion and to add fine lines for wood grain.

For the wallpaper, mix Naples Yellow with some of the brown shadow color from the mullions. Use a no. 6 round to apply a coat of this to the wallpaper area. Dry. Draw the wallpaper pattern over the base coat with a pencil. I used a piece of calico as a reference.

5 FINISH THE WALLPAPER AND PAINT THE WINDOWSILL SHADOWS

Mix Payne's Gray and Permanent Rose to make a soft gray-violet. Paint the wallpaper design, being careful to leave plenty of the base color showing through. Dry.

Mix small puddles of Payne's Gray, Burnt Sienna, Cobalt Blue and Naples Yellow. Using a no. 6 round, paint the shadows under the kittens and along the back edge of the sill. Each shadow is a blended wash starting at the back with Naples Yellow, then working into the center of the sill with a Payne's Gray–Burnt Sienna mix, darkening toward the sill edge. On the right side, farthest from the light source, charge in a little Cobalt Blue. Dry. Paint the front edge of the sill, making the color darker toward the right. Dry again. Then shade with a very dark Payne's Gray–Burnt Sienna mix under the edge of each board. Use a damp brush to soften these shadows as well as those under the kittens.

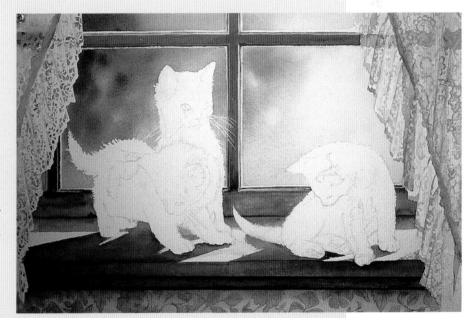

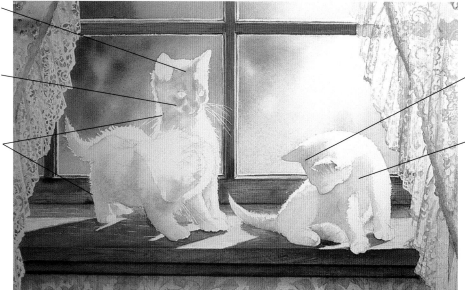

Shadow cores: Payne's
Gray + Permanent Rose
+ Burnt Sienna

Turning points:
Permanent Rose +
Burnt Sienna

Light areas:
Naples Yellow

Shadow cores: Payne's
Gray + Permanent Rose
+ Burnt Sienna

Turning points:
Permanent Rose +
Burnt Sienna

6 BASE WASHES: LEFT KITTEN

Mask the whiskers. Working wet-on-dry with a no. 6 round, paint shadows using the colors indicated above, pulling out to show the roundness of the forms. Blend for soft edges. Dry.

Paint the right side of the face with a no. 4 round, pulling out to show the contour of the nose. With a damp brush, blend the gray tones with the yellow ones so that the transitions are gradual. Save your colors.

7 BASE WASHES: MIDDLE KITTEN

Paint the middle kitten much as you did the left kitten. Notice, however, that the face, which is in the shadow core, is more gray-violet, and the neck is more golden. Also, the cheek, eyebrow and right side of the nose should be lighter, so pull out color in these areas. Keep highlights white and leave a fine white edge on the left side of the face. Again, save your colors.

8 BASE WASHES: RIGHT KITTEN

Use a no. 6 round to paint the base washes on the right kitten. Since this kitten is white, her washes will be mostly gray. Make all of the edges soft by pulling out toward the highlights but not into them; the highlights should stay very white. Save the wash colors.

9 BUILD UP VALUES

Using a no. 4 round and the base wash colors you saved from steps 6, 7 and 8, build up the values and forms, being careful to conserve the white highlights.

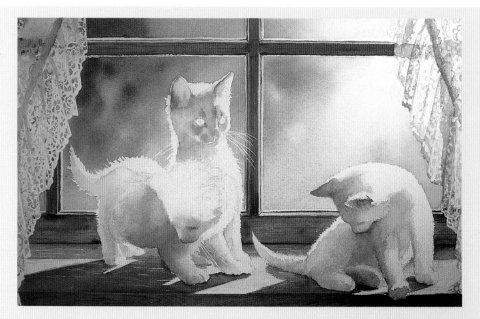

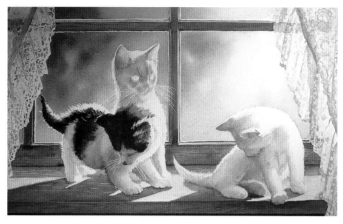

10 PAINT BLACK PATCHES ON THE LEFT KITTEN

On the left kitten, use a masking pen to mask just a few hairs on the inner edge of the right ear and on the back near the highlight. Mix a very dark Payne's Gray and apply with a no. 6 round, pulling out to make the head and belly round and making the color lighter at the upper edges near the highlights. Dry. Dilute the Payne's Gray and add a touch of Burnt Sienna, then use this mix and a no. 2 round to suggest downcast eyes. Dry, then remove the mask. Save your colors.

11 PAINT THE EYES OF THE CENTER KITTEN

For the center kitten's eyes, mix Cobalt Blue and Payne's Gray to make a dark and a light shade of blue. Leaving a tiny white edge and a highlight, paint the eyes with a no. 2 round, using the darker blue around the left edges and the lighter shade around the right. Dry. Just inside the fine white edge, paint a darker line of Payne's Gray, pulling the color down into the inner corners of the eyes. Use a damp brush to soften. Dry.

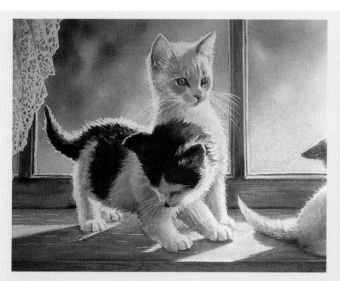

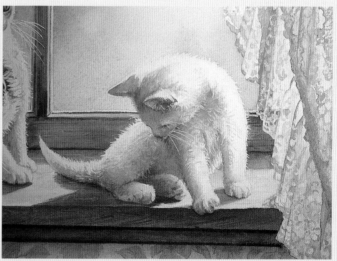

12 FINAL DETAILS

Paint the pupils with Payne's Gray, avoiding the highlights. (If a highlight disappears, retouch it after the area is dry with a tiny dot of white Designer's Gouache.)

Use a no. 2 round and a Payne's Gray–Permanent Violet mixture to paint a few final fur details on all of the kittens, using shading and negative painting to define fur clumps and to accent crevices. Also use this mix to add final details on the lace curtains. Dilute the mixture and glaze the whiskers on the shadow side of the left kitten. Soften any edges on the kittens that are too crisp with a damp no. 4 round.

DEMONSTRATION
Painting Light on White Subjects

This painting is about what happens to white when you add the magic of sunlight. Suddenly, everything white takes on the most amazing colors. The idea came from my Montana cousin who often walks along the Yellowstone to watch the wintering swans. She shared this experience with her mom, who died recently. I like to think of my aunt holding this sparkling morning in her heart, as she did so many beautiful things.

MATERIALS

Watercolors
HOLBEIN: Burnt Sienna • Cobalt Blue • Naples Yellow • Payne's Gray • Permanent Rose • Permanent Violet

Paper
300-lb. (640gsm) cold-pressed, full sheet, edges trimmed to make a narrow composition • Tracing paper

Brushes
1½-inch (38mm) flat • Nos. 2 and 6 round

Other Materials
Masking fluid • Masking pen

The Challenge

As with the kitten project on page 106, the shadows in this painting have to correspond in value with the vivid highlights. So often, a painting of this type can become too pastel to seem real. To prevent this, the pastel tints need to be balanced with muted tones and shades of gray and brown. To avoid making it appear that the swans are levitating over the ice, each shape needs to be grounded with cool, softened shadows underneath and echoed with a crisp, carefully placed reflection.

WINTER DAWN
Trumpeter Swans
Watercolor on 300-lb. (640gsm) Arches cold-pressed paper
13" x 30" (33cm x 76cm)

Sketch

I decided to use a long and narrow horizontal format to show the size of the flock.

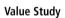

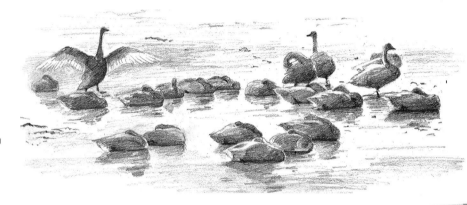

Value Study

There is little real detail in this painting; the form of each bird is described by the patterns of highlight and shadow.

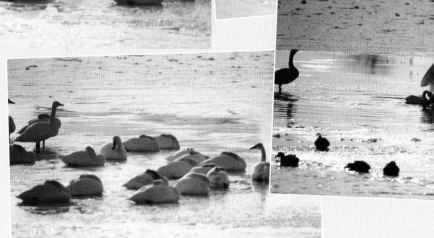

Reference Photos for "Winter Dawn"

Once in a while you get lucky and your references really capture a magic moment. On this icy morning, the resting swans and the lovely light created a perfect mood. I knew the focal point of my painting would be the flapping swan—he provides a bit of action in an otherwise static scene.

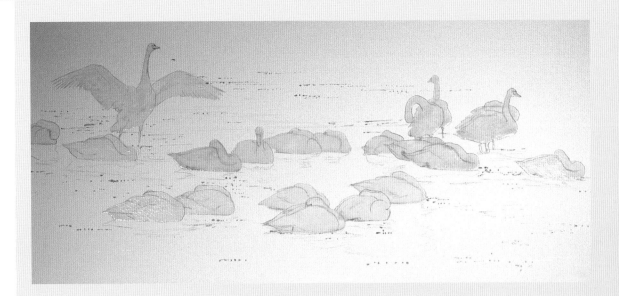

1 DRAW AND MASK THE COMPOSITION

Make a tracing paper transfer, drawing the swans and their reflections carefully. Transfer to the watercolor paper. Mask the swans and also the "sparkle" on the ice. A masking pen works well for lines and dots that denote the sparkle. Much of the sparkle detail is in straight horizontal bands which are finer and closer together in the distance, and larger and farther apart in the foreground. Don't overdo the number of lines and dots. They will be the most dramatic in the darker areas of the wash.

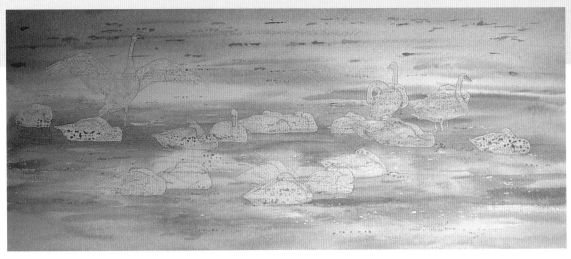

2 PAINT THE WET-INTO-WET BACKGROUND WASH

Mix a large puddle of medium-value Payne's Gray and smaller ones of Permanent Rose and Burnt Sienna. Wet the paper all over with a 1½-inch (38mm) flat. Pick up any excess water; you'll need control for this wash. Apply the Payne's Gray to the upper left, then work downward in horizontal bands. Leave some light areas, especially at the upper right and behind the largest swan. As you get closer to the center, add a little Permanent Rose to the gray. In the foreground, warm the gray with diluted Permanent Rose and Burnt Sienna and apply color in patches. Tilt the paper from side to side (not back to front) to blend. Dry. Save the colors.

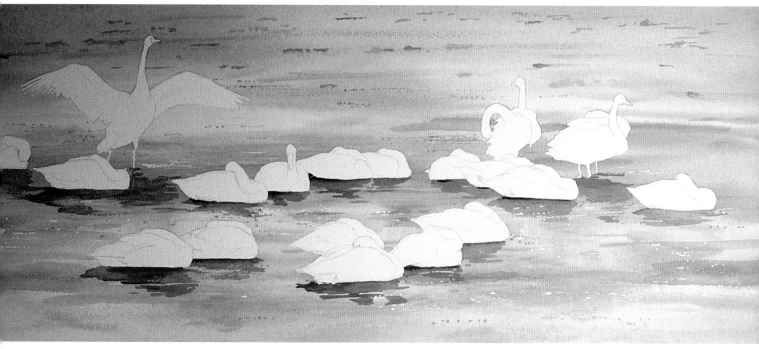

3 REMOVE THE MASK AND PAINT THE REFLECTIONS

Remove the mask from the swans. Using a no. 6 round, paint the swans' reflections. For each reflection, start right under the bird with a dark Payne's Gray, then soften the color and charge in some lighter Payne's Gray, Permanent Rose and Burnt Sienna. Each reflection should then be darker right under the bird, becoming lighter and more colorful at its outer edges. The edges of each reflection should be crisp, but each one should break up into bands and ragged patterns at the edges. Dry. Add more dark color right under each swan and blend this color into the rest of the reflection with a damp brush.

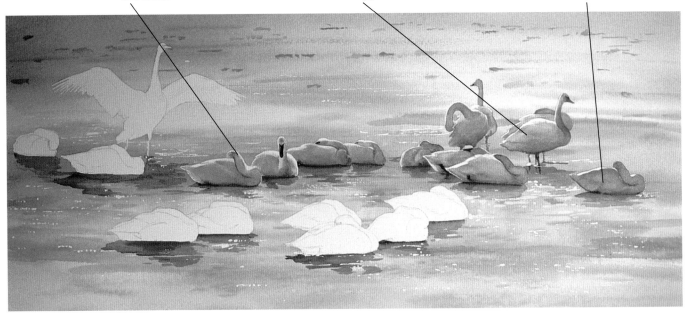

Swans often feed in muddy water, so some may have a little rusty brown color on their heads and necks.

These birds are seen at a distance with the light behind them, so fine feather details aren't visible. Suggest detail with subtle shadows.

Some warm light will reflect from the ice onto the birds.

4 PAINT THE SWANS

Before you paint, think about where the bright sunlight falls on each swan. Redraw highlights if necessary; mask them if you want to.

The Detail Demonstration below shows how to build up the washes on each bird. The light comes from the left, so make the birds' left sides lighter and more colorful, the right sides darker and grayer. Vary the colors for each bird using pinks and violets, but keep these subtle and realistic.

DETAIL DEMONSTRATION: Swans

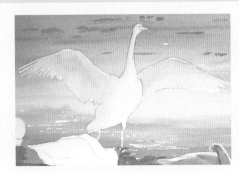

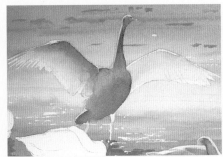

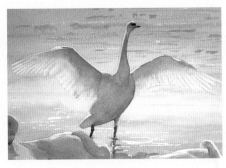

1 PAINT THE BASE WASH

Without pre-wetting the swans, paint the warmest and palest areas with light Naples Yellow, shading into a little pale Burnt Sienna and Permanent Rose. Pull out to keep the inside edge soft. Dry.

2 ADD GRAY-VIOLET AND GRAY-BLUE

Mix a gray-violet out of Payne's Gray and Burnt Sienna, and a gray-blue using Payne's Gray and Cobalt Blue. Pull the gray-violet down into the yellow wash without completely covering it. Use the gray-blue for lighter areas. Dry.

3 PAINT THE SHADOW CORE AND FINAL DETAILS

Mix Payne's Gray and Burnt Sienna for a dark, neutral gray. Paint this on the shadow core areas, pulling out into the previous wash. Also use this mix to suggest places where feathers or body parts overlap. Paint the bill and legs with Payne's Gray.

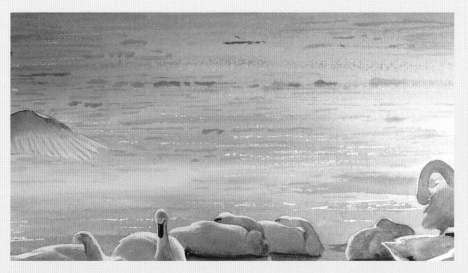

5 REVEAL THE SPARKLE AND ADD A FEW STROKES OF COOL COLOR FOR DEPTH

Remove the mask from the ice to reveal the sparkle. Using a no. 6 round, add a few bands of cool color to the background ice with a Cobalt Blue–Payne's Gray mix. If you didn't add quite enough character to the ice initially with a masking pen, you can use a craft knife to gently scratch out a few specks of bright sparkle—but be careful not to go too deep and damage the paper.

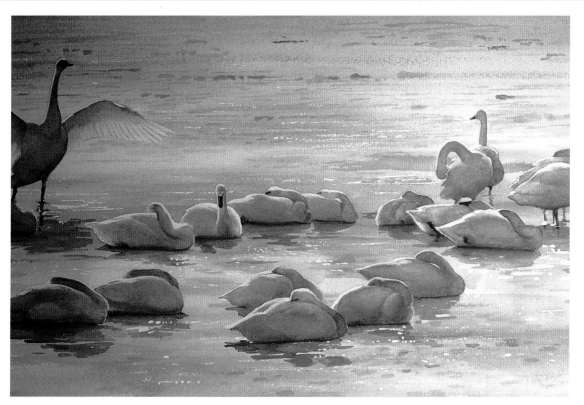

6 ADD TOUCHES OF WARM COLOR TO THE FOREGROUND

Use a no. 6 round to paint a few strokes of light Naples Yellow on the ice around the closest swans on the right to suggest sunlight. For a bit more depth and texture, mix a pale combination of Burnt Sienna and Permanent Violet and add a few strokes here and there in the near foreground from the closest swans to the lower edge of the painting.

DEMONSTRATION
Soft Light

My grandmother, who grew up on an Iowa farm, used to say that the mourning dove's mournful, minor-note coo was a lament: "Old cow ruined me, me, me!" I've enjoyed hosting a pair of mourning doves on my property for the last few years and I smile every time I hear that call.

The Challenges

This painting is different from our other three projects in that the lighting, while just as important to the painting, is soft and diffused. The colors are also softer, chosen to complement the tones of sienna, blue and gray in the doves' plumage. I saw the crumbling brick wall, actually part of the ruins of an old plantation, in South Carolina. It was interesting to me because of the various textures—the little clump of volunteer ferns, the moss, the old mortar and the ancient bricks.

MATERIALS

Watercolors
HOLBEIN: Burnt Sienna • Greenish Yellow • Naples Yellow • Payne's Gray • Raw Umber • Rose Violet • Sap Green • Shadow Green • Viridian

Paper
300-lb. (640gsm) cold-pressed, one-half sheet, 22" x 15" (56cm x 38cm)

Brushes
1½-inch (38mm) flat • Nos. 2, 4, 6, 8 and 10 round • Nos. 2 and 6 synthetic rounds for masking

Other Materials
Masking fluid • Masking pen • Table salt

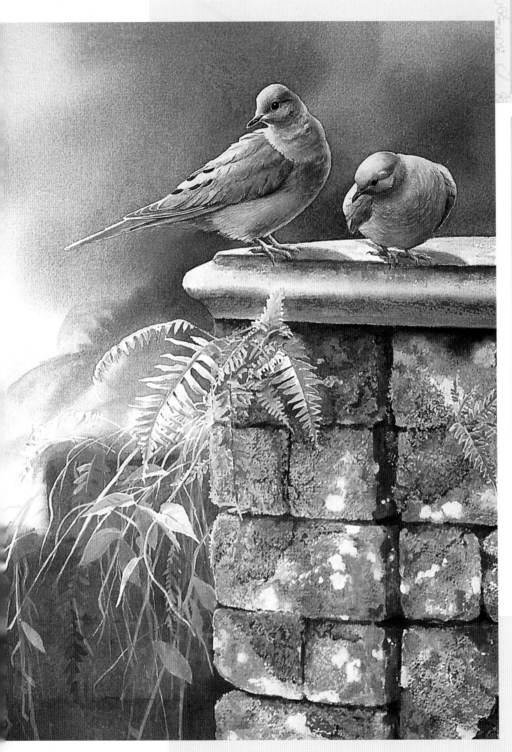

WALLFLOWERS
Mourning Doves
Watercolor on 300-lb. (640gsm) Arches
 cold-pressed paper
22" x 15" (56cm x 38cm)

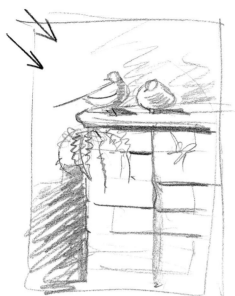

Sketch

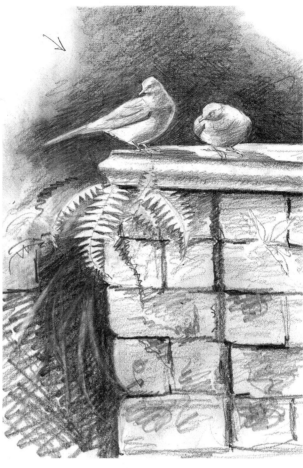

Value Plan

In this composition, the light is subdued, with just a hint of brightness from behind—perfect for revealing texture, but hard to read correctly. There was enough evidence of light direction in the references that I had to alter the light on the doves and imagine just a hint of cast shadow.

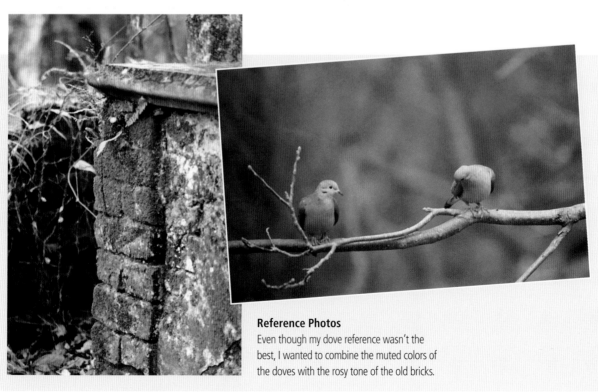

Reference Photos

Even though my dove reference wasn't the best, I wanted to combine the muted colors of the doves with the rosy tone of the old bricks.

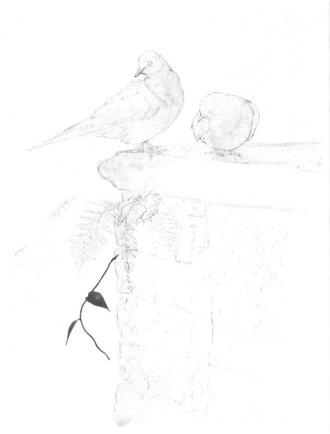

1 DRAW AND MASK THE COMPOSITION

Draw the composition on tracing paper and transfer it to watercolor paper. Only the birds, the edges of the wall and a few of the ferns and trailing plants need to be masked. Use a synthetic no. 6 round to mask the large areas, switching to a no. 2 synthetic round for the beak, legs and tail. For the foliage, use a no. 2 synthetic round or a masking pen, as I did here for the vine.

2 PAINT THE UPPER PART OF THE WET-INTO-WET BACKGROUND

Mix puddles of Shadow Green, Burnt Sienna and Payne's Gray, and a small one of Viridian. Also mix a little white Designer's Gouache with water to a creamy consistency.

Using a 1½-inch (38mm) flat, wet the entire background, then quickly apply a light coat of the gouache to the upper two-thirds of the background. While this is still wet, mix Payne's Gray with Shadow Green and a bit of Viridian (a little Viridian goes a long way). Work this dark color in around the birds with a no. 10 round, then blend it upward with a 1½-inch (38mm) flat. Rinse and blot the brush, then use a very diluted Viridian–Payne's Gray mix to paint the lighter areas. Add some Burnt Sienna to the green-gray mix to make a medium brown. Brush this into the background here and there, then tilt the paper to blend the colors. Let dry until the shine is gone. Suggest a few fern fronds with the Viridian–Payne's Gray mix and a barely wet no. 6 round. Dry thoroughly with a hair dryer; this wash must be bone-dry before the next step.

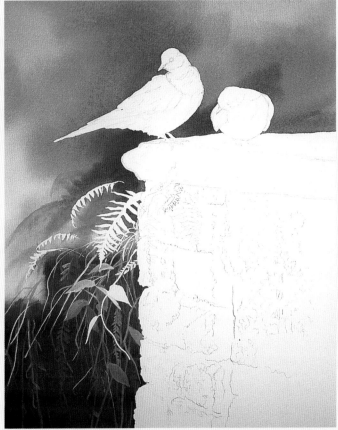

3 PAINT THE LOWER HALF OF THE BACKGROUND

Mix a large puddle of a dark Payne's Gray–Burnt Sienna mix, a smaller puddle of concentrated Burnt Sienna, and a smaller puddle of Greenish Yellow mixed with a little Burnt Sienna.

Using a 1½-inch (38mm) flat, wet the lower portion of the background, pulling the water up slightly into the foliage area right under the rim of the wall. Paint the background brick wall with the dark Payne's Gray–Burnt Sienna mixture. While this is still wet, pick up some of the concentrated Burnt Sienna and paint horizontal bands over the dark Payne's Gray–Burnt Sienna mix, leaving spaces of dark gray for mortar. At the top edge of the background wall, paint a little of the Greenish Yellow mix with a no. 10 round, allowing color to blend down into the brick area and also up into the background. Dry. Refer to the next step for instructions on painting the ferns.

4 SUGGEST BACKGROUND LEAVES AND FERNS

Mix bleedproof white with Sap Green and also with Burnt Sienna. Remember that these mixes, being opaque, will dry darker than they appear on the palette, so mix them lighter than you think they need to be. Using these mixes and a no. 2 round, paint a few leaves and ferns over the background wall wash. The effect should not be too stark; allow the colors to blend into the background just a bit. Dry, then remove the mask.

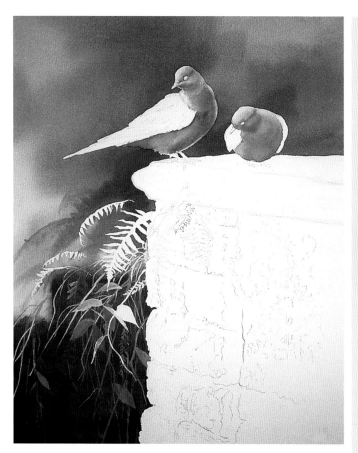

5 PAINT THE FIRST WASHES ON THE DOVES

On your palette, mix small puddles of Burnt Sienna, Payne's Gray and Rose Violet. Lightly wet and then paint one bird at a time in the following manner: Wet only the head and body, excluding the wings and tail. Mix a little Rose Violet into the Burnt Sienna and use the no. 6 round to paint the head, breast and body, pulling out to conserve the highlights. While the color is still a little wet, mix some Payne's Gray into the Burnt Sienna–Rose Violet mixture to make a dark gray. Paint this into the core shadow area on each bird, pulling out to blend smoothly and again avoiding the highlight areas. Dry. Save your colors.

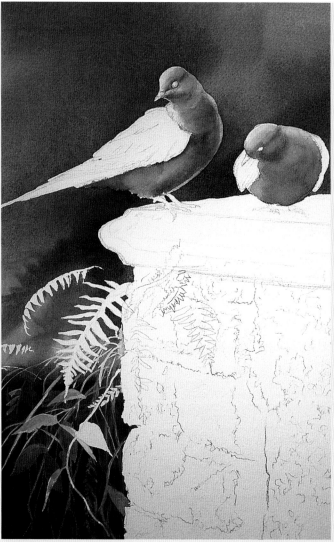

6 BUILD UP THE WASHES

Build up the values on the doves by repeating the colors and techniques used in Step 5.

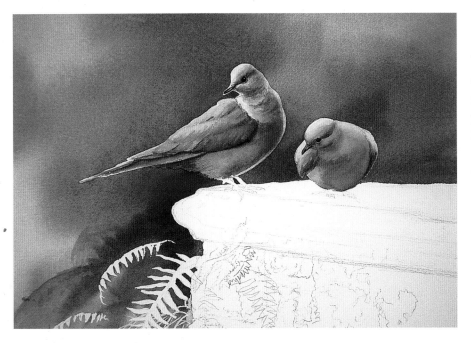

7 PAINT THE WINGS AND FEATURES

Using a no. 6 round, lightly glaze the wing areas with a pale Burnt Sienna–Rose Violet mix, conserving the highlights. Dry. Mix a puddle of Payne's Gray with just a little Burnt Sienna and Rose Violet to make a dark purple-gray (not too purple). Apply this to the wings with a no. 6 round, conserving the light areas. Dry. Make a darker mix of the same colors. Use a no. 4 round to paint shadows under the feather groups and a few details on the wings. Use Payne's Gray and a no. 2 round to paint the eyes and beaks, conserving the highlights. Leave a tiny light rim around each eye by painting a darker line under the rim. Save your colors.

8 ADD DETAILS TO THE BIRDS AND THE WALL

Using a no. 2 round, build up the dark gray details on the doves, pulling out under the feathers to soften. Using Payne's Gray alone, paint the dark spots on the wings. If you wish, remask the feet and the fern that overlaps the top of the wall.

Using a no. 6 round, paint the wall's top edge with a very light glaze of Payne's Gray and Rose Violet, avoiding the fern and the birds' feet unless they are masked. Dry. Make a darker mix of the same color and use this to paint the upper and lower borders of the concrete edge, pulling out to create the highlight in the middle. Work the color around the fern. Dry, then drybrush this same color along the top edge to make the concrete look rough. Paint the birds' shadows with this mixture also. Mix a little Naples Yellow into some bleedproof white and add a few delicate strokes for feather details.

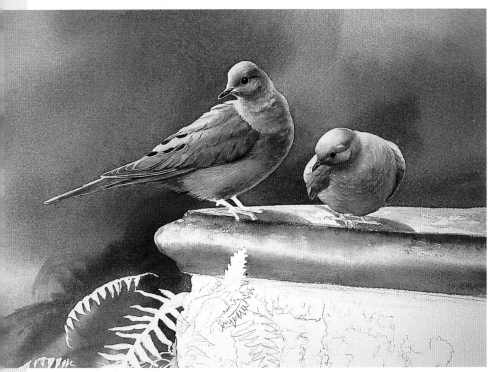

9 ADD SALT TEXTURE TO THE BRICKS

Mask the ferns that overlap the bricks. While the mask dries, mix the following puddles: Shadow Green, Sap Green, Burnt Sienna and Rose Violet. Use a no. 8 round to paint the non-mossy areas of the bricks with Burnt Sienna and Rose Violet, mixing these in different combinations to vary the colors. Paint the mossy areas with mixtures of Sap Green and Shadow Green, making the color very dark just under the rim of the wall. Using a mix of Payne's Gray and Burnt Sienna, paint the divisions between the bricks. Allow these washes to dry until the shine just starts to disappear, then sprinkle the bricks with salt. Use more salt on some bricks than on others so the effect won't be too uniform. Let dry (do not use a hair dryer).

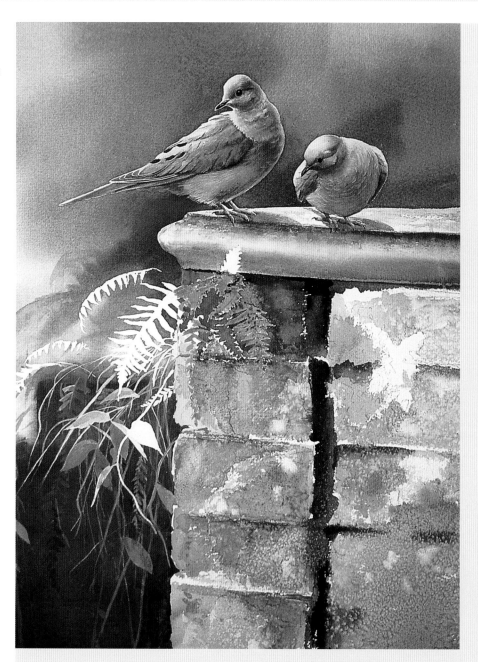

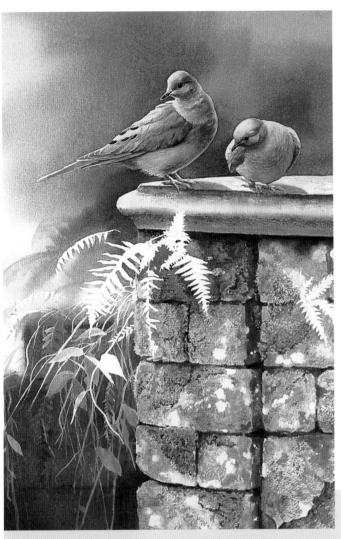

10 PAINT DETAILS AND MOSS TEXTURE ON THE BRICKS

Using a no. 6 round, drybrush some of the bricks with a dark gray-brown mix of Burnt Sienna, Rose Violet and Payne's Gray, being careful not to cover the salted areas. Use the same dark mix to paint a few cracks and other details. Drybrush a few patches of golden-colored lichen with a mix of Raw Umber and Burnt Sienna.

Add some drybrushed details to the moss with Shadow Green. Give dimension to the moss and lichen patches by adding darker edges underneath for shadows. If you wish, you can make some mixtures of white Designer's Gouache with Sap Green and Greenish Yellow and add few more fern fronds and lichen patches with a no. 4 round. Shade underneath them with the Payne's Gray mix after drying.

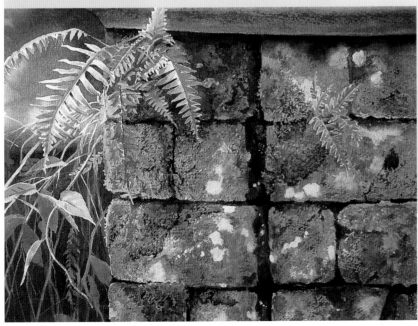

11 PAINT THE FERNS AND VINES

Using nos. 4 and 2 rounds, paint the leaves and ferns with mixtures of Sap Green and Shadow Green, making them darker on the sides away from the light or close under the wall edge. Dry as needed to avoid colors running together. Paint the dead leaves with mixtures of Raw Umber and Burnt Sienna.

Index

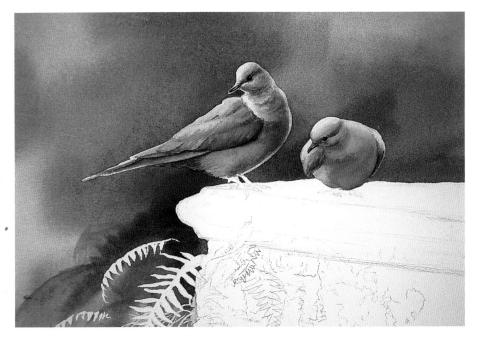

7 PAINT THE WINGS AND FEATURES

Using a no. 6 round, lightly glaze the wing areas with a pale Burnt Sienna–Rose Violet mix, conserving the highlights. Dry. Mix a puddle of Payne's Gray with just a little Burnt Sienna and Rose Violet to make a dark purple-gray (not too purple). Apply this to the wings with a no. 6 round, conserving the light areas. Dry. Make a darker mix of the same colors. Use a no. 4 round to paint shadows under the feather groups and a few details on the wings. Use Payne's Gray and a no. 2 round to paint the eyes and beaks, conserving the highlights. Leave a tiny light rim around each eye by painting a darker line under the rim. Save your colors.

8 ADD DETAILS TO THE BIRDS AND THE WALL

Using a no. 2 round, build up the dark gray details on the doves, pulling out under the feathers to soften. Using Payne's Gray alone, paint the dark spots on the wings. If you wish, remask the feet and the fern that overlaps the top of the wall.

Using a no. 6 round, paint the wall's top edge with a very light glaze of Payne's Gray and Rose Violet, avoiding the fern and the birds' feet unless they are masked. Dry. Make a darker mix of the same color and use this to paint the upper and lower borders of the concrete edge, pulling out to create the highlight in the middle. Work the color around the fern. Dry, then drybrush this same color along the top edge to make the concrete look rough. Paint the birds' shadows with this mixture also. Mix a little Naples Yellow into some bleedproof white and add a few delicate strokes for feather details.

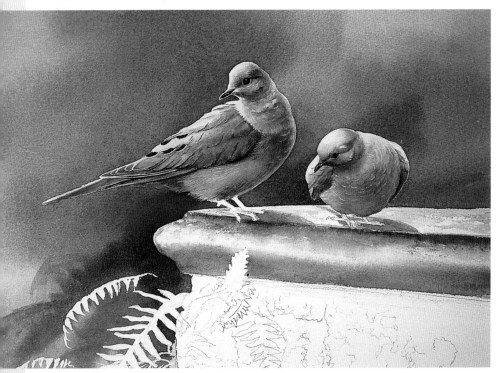

9 ADD SALT TEXTURE TO THE BRICKS

Mask the ferns that overlap the bricks. While the mask dries, mix the following puddles: Shadow Green, Sap Green, Burnt Sienna and Rose Violet. Use a no. 8 round to paint the non-mossy areas of the bricks with Burnt Sienna and Rose Violet, mixing these in different combinations to vary the colors. Paint the mossy areas with mixtures of Sap Green and Shadow Green, making the color very dark just under the rim of the wall. Using a mix of Payne's Gray and Burnt Sienna, paint the divisions between the bricks. Allow these washes to dry until the shine just starts to disappear, then sprinkle the bricks with salt. Use more salt on some bricks than on others so the effect won't be too uniform. Let dry (do not use a hair dryer).

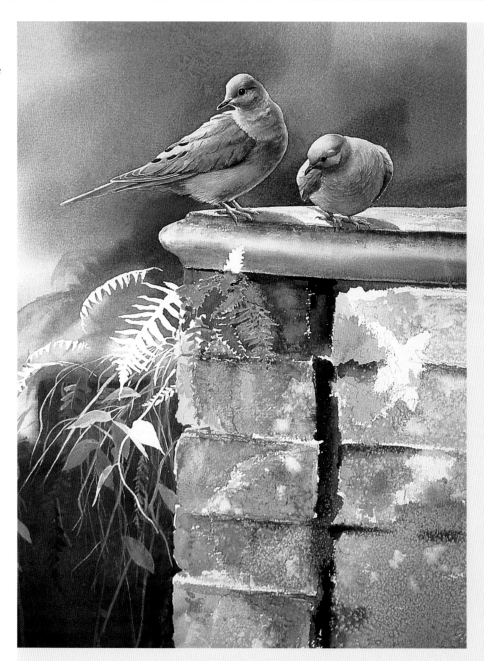

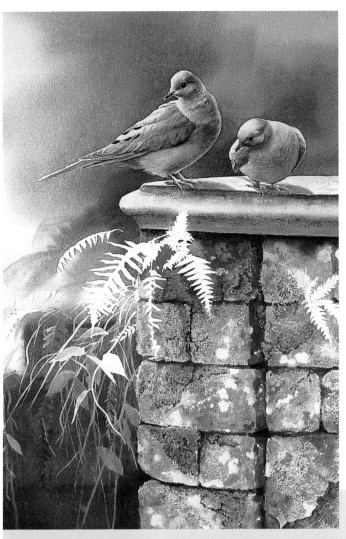

10 PAINT DETAILS AND MOSS TEXTURE ON THE BRICKS

Using a no. 6 round, drybrush some of the bricks with a dark gray-brown mix of Burnt Sienna, Rose Violet and Payne's Gray, being careful not to cover the salted areas. Use the same dark mix to paint a few cracks and other details. Drybrush a few patches of golden-colored lichen with a mix of Raw Umber and Burnt Sienna.

Add some drybrushed details to the moss with Shadow Green. Give dimension to the moss and lichen patches by adding darker edges underneath for shadows. If you wish, you can make some mixtures of white Designer's Gouache with Sap Green and Greenish Yellow and add few more fern fronds and lichen patches with a no. 4 round. Shade underneath them with the Payne's Gray mix after drying.

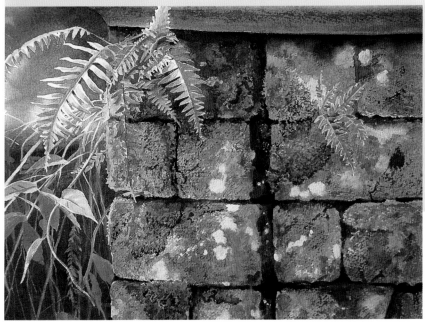

11 PAINT THE FERNS AND VINES

Using nos. 4 and 2 rounds, paint the leaves and ferns with mixtures of Sap Green and Shadow Green, making them darker on the sides away from the light or close under the wall edge. Dry as needed to avoid colors running together. Paint the dead leaves with mixtures of Raw Umber and Burnt Sienna.

Index